695

Simcoe, Ontario: Preparations for Sir Wilfrid Laurier's visit, 1909. Photographed by James & Son (CTA/James 586).

ROGER HALL & GORDON DODDS

CANADA
A HISTORY IN PHOTOGRAPHS

Hurtig Publishers

Copyright © 1981 by Roger Hall and Gordon Dodds

No part of this book may be reproduced or transmitted in any form by any means, electronic or mechanical, including photocopying and recording, or by any information storage or retrieval system, without written permission from the publisher, except for brief passages quoted by a reviewer in a newspaper or magazine.

Hurtig Publishers Ltd.
10560–105 Street
Edmonton, Alberta

Canadian Cataloguing in Publication Data

Hall, Roger, 1945–
　Canada, a history in photographs

　Includes index.
　ISBN 0-88830-202-9

　1. Canada — History.　I. Dodds, Gordon,
II. Title.

FC174.H34　　971　　C81-091183-3
F1026.H34

Printed and bound in Canada
by T. H. Best Printing Company Ltd.

Abbreviations

ACC	Anglican Church of Canada
ACR	Archives of the Canadian Rockies
ANQ	Archives Nationales du Quebec
ANQM	Archives Nationales du Quebec à Montréal
BTC	Bell Telephone Company Archives
COA	City of Ottawa Archives
CP	Canadian Pacific Archives
CRCCF	Centre de Recherches de Civilisation Canadien-Français
CTA	City of Toronto Archives
CVA	City of Vancouver Archives
DND	Department of National Defence
DUA	Dalhousie University Archives
EA	Eaton's of Canada Archives
GA	Glenbow-Alberta Institute
IOA	Imperial Oil Archives
McG	McGill University Archives
NBM	New Brunswick Museum
NFB	National Film Board
NPA	Notman Photographic Archives
OA	Ontario Archives
PAA	Provincial Archives of Alberta
PABC	Public Archives of British Columbia
PAC	Public Archives of Canada
PAM	Provincial Archives of Manitoba
PANB	Provincial Archives of New Brunswick
PANL	Provincial Archives of Newfoundland and Labrador
PANS	Public Archives of Nova Scotia
PAPEI	Public Archives of Prince Edward Island
SAB	Saskatchewan Archives Board
SPL	Saskatoon Public Library
UCC	United Church of Canada
US	University of Saskatchewan
UTA	University of Toronto Archives
VPL	Vancouver Public Library
YA	Yukon Archives
YU	York University Archives

Contents

	Foreword / 7
ONE	Her Majesty's Dominion / 11
TWO	Promises of Youth / 31
THREE	"Canada's Century" / 75
FOUR	Tribal Obligations / 125
FIVE	Rich Man, Poor Man... / 145
SIX	...Beggarman, Thief / 169
SEVEN	A Necessary Evil / 189
EIGHT	The True North / 215
NINE	Even in the Best of Families / 237
EPILOGUE	Plus ça change / 253
	Index / 256

*For
Jeffrey
Michelle
and
Stefan*

Edmonton, Alberta: 1911 (PAA/A-2017).

Foreword

Generations of Canadians have fretted about their elusive nationality. "Looking for Canada" has become a national pastime, a search fuelled by zealots wanting either to erase the hyphens and homogenize us all or to pronounce us a unique multicultural mèlange. The constitutional wranglings among Ottawa and the provinces in the early 1980s have forced Canadians to reassess their political and economic relationships. In one sense, we are confident of where we stand geographically — Canada is where we live and what we are doing from day to day; in quite another sense, we reel from pillar to post, buffeted by so many political, economic, and cultural crusades.

In *Canada: A History in Photographs* we make no particular claim to soothing our national schizophrenia. Indeed, we are probably picking at already-exposed nerves. Still, our feeling is that the very act of searching for Canada may well come closest to what we are about. There doesn't need to be a final resolution to the dilemma; at least half the satisfaction comes from tearing up the plant to see whether the roots are fresh and growing despite the drooping foliage.

Canada's professional "root-hounds" are its historians and writers. The latter employ every device they can muster to pick and probe, but the historian is usually governed by methodologies and always by materials. The traditional Canadian approach to history has been to study "great figures" in political life based on their personal manuscripts. Only in recent years have historians broken with tradition as European and, more frequently, American methods have found their way into investigating Canada's past. Most notably, labour historians have been raising working people into historical daylight through careful study of their records (some of it photographic), and "cliometricians," exponents of the so-called new history, have been trying to grasp a total picture of the past by juggling huge masses of seemingly disconnected statistics in local government records. These views of Canadian society are based on the realisation that the past is not a tangible, definable commodity to be packaged and sold for instant gratification. The past is infinitely more complex and multi-dimensional than we would expect from reading Canada's traditional written history.

Some of this complexity can be sensed by looking at the kinds of records we have preserved in archives, museums, and libraries. Contact with these records, in one form or another, helps us to connect with that much-abused aspect of our daily lives: our heritage. Written, graphic, printed, electronic, and cartographic records, in addition to artifacts, buildings, and landscapes, can bring the past and present together in a thousand different notions and experiences. Naturally, not all of these can or should be translated into book form. Experimental miracles like videodisc, a means of both storing and bringing together records of all kinds at speed, in bulk, in varied and multiple forms and in colour, are not yet available for domestic consumption. Until they do reach a mass market, however, the book remains our most attractive and durable mode of communication.

Until quite recently, one prolific and engaging record of our past — the still photograph — has been employed with very little imagination in Canada's history books. Rarely has the photograph been seen as an archival medium in its own right, a source material with its own virtues and problems. The historical value of the photograph has to be weighed carefully against that of other records in other media — the letter, office file, personal diary, project report, accounts ledger, statistical return, voucher, register, watercolour, pen-and-ink sketch, oil painting, cine-film, sound recording, map, computer record, blueprint, and so on. More often than not, the photograph has been merely dropped into a printed text to "liven it up," to give "colour," to provide a glimpse of "reality"; in short, to *illustrate* the written word. Sometimes this is not badly done, but invariably it fails to take full advantage of an important and dramatic source.

Our book is *not* an illustrated history, nor is it a mock-antique bow to the nostalgia trade in photographs or a specialized study of photography in Canada. It is simply a photographic record of Canada — from Confederation (1867) to Constitution (1981). Through a blend of selectivity and serendipity, we have tried to do with photographs what might be attempted with maps, paintings, or manuscripts: present a story along a chain of time, defined by two official benchmarks admittedly, but coincidentally and happily following the birth and growth of photography itself.

We are aware of gaps and imbalances in a photographic record spanning so many years; at some times it was literally impossible to find suitable material, at others we were forced to reject imagery which was too static or sombre. And, as we neared the late 1970s, we drew back from journalism and any attempt to represent a spectrum of "current issues." We have avoided "great moments in Canadian history." The Last Spike is not driven in these pages yet again. Our guess is that readers will discover in such a visual display many more thoughts and connections about the history of Canada than they had previously thought possible. That is as it should be in a medium as seductive as photography. The camera, of course, does lie, most often when it seems to be generating the most attractive imagery. We have made no attempt to separate all the fickle images, but we do suggest that things are not always as they appear. Objectivity is perhaps as elusive as the search for Canada.

In gathering materials for this book over the past three years, we have travelled from Newfoundland to Victoria, and examined nearly a million prints and negatives which we have pared down to fewer than five hundred for publication. We made no forays into private photographic collections

beyond one or two corporate archives. Quite deliberately we confined our attention to holdings in the public sector, to Canada's many public archives, libraries, museums, and galleries. For the following colleagues and friends in these repositories, who gave so readily of their assistance and bore our demands with serenity, we record our appreciation: Laurenda Bagley, John Bell, Hart Bowsfield, Margaret Campbell, Marcel Caya, Margaret Chang, Fred Farrell, Elizabeth Gerachty, Jean Goldie, D'Arcy Hande, Stan Hanson, Al Harrington, Ted Hart, David Hughes, Gary Hughes, Scott James, Dorothy Kealey, Georgeen Klassen, Celine Larivière, Ronald Le Blanc, Wilbur Lepp, Glenn Lucas, Marjorie MacDougall, Ken Macpherson, Louise Minh, David Neufield, Linda Price, Scott Robson, Lloyd Rodwell, Louise Roy, Brian Speirs, Stan Triggs, Joy Williams, Ian Wilson, and Fay Wood.

Our thanks for their constant support and encouragement go to Sandra Martin and Marietta Dodds. Peter Bower and Marion Beyea deserve special mention for their friendship and hospitality and we are particularly appreciative of the help given by Fred Armstrong, Judith Beattie, Bruce Bowden, Nicholas der Jong, and Roy Schaeffer. We are also grateful to Michael Swift of the Public Archives of Canada and to our editor, Sarah Reid. Our thanks go also to Carmen Callon for typing and to David Shaw for his design.

30-31 Vict. c.3, 1867
(PAC/C-48989, from an original in the House of Lords Record Office, London).

ANNO TRICESIMO

VICTORIÆ REGINÆ.

CAP. III.

An Act for the Union of *Canada, Nova Scotia*, and *New Brunswick*, and the Government thereof; and for Purposes connected therewith. [29th March 1867]

WHEREAS the Provinces of *Canada, Nova Scotia*, and *New Brunswick* have expressed their Desire to be federally united into One Dominion under the Crown of the United Kingdom of *Great Britain* and *Ireland*, with a Constitution similar in Principle to that of the United Kingdom:

And whereas such a Union would conduce to the Welfare of the Provinces and promote the Interests of the *British* Empire:

And whereas on the Establishment of the Union by Authority of Parliament it is expedient, not only that the Constitution of the Legislative Authority in the Dominion be provided for, but also that the Nature of the Executive Government therein be declared:

And whereas it is expedient that Provision be made for the eventual Admission into the Union of other Parts of *British North America*:

Be it therefore enacted and declared by the Queen's most Excellent Majesty, by and with the Advice and Consent of the Lords Spiritual

"La Regne le Veult" — so Queen Victoria in the thirtieth year of her reign indicated her approval, in the archaic phrasing of Norman French reserved in England for such occasions, of the parliamentary statute placing Canada East (Quebec), Canada West (Ontario), Nova Scotia, and New Brunswick under one united government. Her Majesty's newly constituted "One Dominion under the Crown of the United Kingdom of Great Britain and Ireland" thus became, as of July 1, 1867, subject to the British North America Act.

This most important of all the British laws to have affected Canada set the small eastern group of four provinces on a path to complete independence from colonial government, not least by providing for their expansion and "the eventual admission into the Union of other Parts of British North America" — Prince Edward Island perhaps, lying east of the New Brunswick coast; or Newfoundland, the ancient fishing colony in the mouth of the St. Lawrence River; or British Columbia far on the rim of the Pacific Ocean; or even a part of the great western prairies which still lay under the vast commercial control of the highly organized British fur-trading concern, the Hudson's Bay Company. The constitution established for Canada by the Act ostensibly gave to its citizenry the rights held by British subjects, evolved not by statute but from centuries of common law, habit, and experience. No "Bill of Rights" was deemed necessary, as it had been by her republican southern neighbour and as it would be by the Canadian government's proposal for "patriation" of the British North America Act in the 1980s. The Act provided for a distribution of power between a federal Parliament and provincial legislatures, but reserved to Ottawa alone the right of requesting amendment from the British at Westminister.

Requesting change or surrender of the Act from Britain still must be done before Canada can pass its own Constitution. Yet Canada in 1981, despite at least eighteen major changes to the Act since 1867 and a host of political and economic variations unseen by the lawgivers of the 1860s, is curiously and marvellously bound by the statutory provisions of the Act. The seething provincial voices of the 1980s which demand federal consideration, but *have no right* to it constitutionally, seem at times to parallel the furious Nova Scotian delegates of 1867 who raged at the apparent indifference of British MPs who vacated the Commons chamber during the passage of the British North America Act, yet returned *en masse* subsequently to debate dog-tax legislation. The "Interests of the British Empire," as the Act put it in 1867, have unquestionably given way to the "Welfare of the Provinces" in 1980 and the debate has become Canadian rather than British.

ONE

Her Majesty's Dominion

Canada has been dismissed as no more than a geographic expression. Whatever its elusive identity, certainly on its first birthday, July 1, 1867, it appeared as little else. That day both cheers and jeers greeted the declaration of the Dominion, a term used so as not to give offense to the neighbouring republic. In Ontario it was, according to the Toronto *Globe*, a "gladsome morn"; in Quebec great doubts clutched the French-speaking populace, fearful that they might soon be swamped in a sea of English; and in the Maritimes, a goodly number celebrated with black bunting and even mock funeral masses.

In a sense nothing very momentous had really occurred. Three British colonies in North America had joined in a federation and, by constitutional legerdemain, had created four provinces, Nova Scotia and New Brunswick in the east and Quebec and Ontario in the west. They shared certain prejudices and predilections — chief among which was a healthy distrust of their American neighbours — as well as certain strong institutions, the particular and political inheritance of their English mother. For that mother, shrinking at that point from her colonial responsibilities, especially the fiscal ones, the union seemed a splendid plan. Britain would still administer the colonies' (and her own) external interests, but could engage in fruitful trade without the cloying and costly colonial preferences, and avoid becoming enmeshed in testy problems of purely local concern.

The idea of betterment of trade had been a prime factor in the formation of the new country. Doubtless the creation of a proud new nationality was there too, but for most people, practical matters were paramount. The new country, it was agreed, would form a large, tidy, and profitable common market. It would have a better credit rating, it could lay substantial territorial claims to the distant, beckoning prairie "North-West," and it could form a firmer bulwark against swaggering American intrusion into colonial business. There were other good external reasons — mostly American in derivation. The United States, fresh from its victory over the Confederate South, still smarted over Britain's support of the South's cause. Fears of the powerful Union Army stalking north to lunge at Britain's Canadian underbelly had recently been tempered by independent Irish

Fenian raids across the border. The American Civil War was not only a catalyst for the Canadian federation; it also helped to define the nature of the constitutional structure. Canada would not be like ante-bellum America, a nation with a weak central government and strong constituent parts. It would, despite the title *confederation*, not be a league of states but a true federation with the constituent parts clearly subordinate to a powerful central government.

The new federation had been developed as well to solve the rigid political deadlocks that had plagued Canadian union. Politically, Nova Scotia and New Brunswick had developed without rancour or rebellion from their Loyalist and traditional roots to mature self-governing colonies. By contrast, central Canada had long been a cauldron. The old French province of Quebec had been divided into two halves in 1791. The Imperial administration of that day had failed to provide satisfactory linkage between the executive and the legislature. Finally, in the wake of open rebellion in the Canadas in the 1830s — and as a result of Britain's growing interest in free trade — responsible cabinet government had been granted in the late 1840s to all the principal British North American colonies. For the unruly Canadas, Lord Durham, the Imperial investigator of the rebellions, urged a political and legislative union which was effected in 1840. The difficulty was that legislative representation was fixed at that stage, and although the populations of both sections, Canada East and Canada West, grew, the growth-rate in Canada West was much faster. Cries of "Rep by Pop" — representation according to population — were heard throughout the 1850s. Moreover, the idea of "sectionalism," of the identification of certain political groups and parties with their own eastern or western region, made it most difficult to gain a majority from both sections of the colony. Political deadlock was the frequent result, and the new federation was seen as a way of retaining control of local matters at the local level while at the same time allowing participation in a larger political arena. The process had been initiated with Canada's attendance at the Charlottetown Conference of 1864, originally slated as a forum for Maritime union only. The fundamental understanding reached there was refined through further discussions at Quebec and hammered out in rough form at the London Conference in 1866. All the particulars were then hastily assembled into an Imperial Bill and passed as the British North America Act in the spring of 1867.

The earth did not exactly tremble on this occasion. Indeed, the chamber of the House of Commons was nearly empty, although a few minutes later the place was jammed for debate of a domestic dog tax.

What, precisely, had been launched? The geographical expression was easy enough. Canada, comprising four provinces, stretched from sea unto Lake Huron and had an imprecise border to the north and west. It was rural rather than urban, and its population was an unimposing four million; most were of British origin, the rest French.

The new nation, however, had certain other distinctive characteristics and postures which would, as it turned out, continue to characterize it. It was a country of regions — regions which frequently suggested that Canada was not and would never be anything more than the sum of its parts. It was a country forced to engage from the beginning in a precarious balancing act — between omnivorous, ubiquitous American pressures and fading but substantial British influences and traditions. It was also a country at one and the same time English as well as French and French as well as English.

Montreal, Quebec: 1863. Photographed by William Notman (NPA 841301).

At Confederation the premier city of the new Dominion was Montreal, a thriving centre of international commerce with a population of nearly a hundred thousand. Scottish businessmen were pre-eminent in guiding the city's development, engaging in the harvests of timber and fur, and in railroading, and pocketing handsome profits. Their money was made amongst the buildings and activities seen in this view eastward from Notre Dame church, but they lived and played in the dourly handsome streets to the west, around McGill College on the lower slope of Mount Royal. The British presence can be glimpsed, too, across the harbour on Île Ste Hélène, in white triangular tents perhaps belonging to the Royal Artillery unit stationed on the island. Yet the buildings and streets here are unmistakably French — mostly of rough stone with high fire walls. The convent of Les Dames de la Congregation is in the foreground just behind the church of Notre Dame des Victoires, and the dome of the Bonsecours Market glistens in the slanting sunlight. In the view of Place Jacques Cartier, with its youthful Neptune facing the plinth celebrating Nelson's victory over the French at Trafalgar in 1805, there is a gaiety and casualness seldom found in photographs from early cameras.

Montreal, Quebec: c. 1867 (PAC/PA-12670).

Hyphenated Canadianism made a uniform definition of the new nationality almost impossible.

Certain other constancies were also evident. Canadians early on saw inadequacies in their imperfect constitution, a document viewed as too flexible by some (because so much was unwritten) and not flexible enough by others (because what was written was so uncompromising). Canada was a compromise with mixed cultural inheritance and without much sense of nationhood. For most people in 1867 Canada's context was within the British Empire. The BNA Act was not a declaration of independence at all, but a declaration of *dependence*, of continuity and maintenance of the British link, and perhaps the forerunner of a kind of Imperial federalism. Smaller groups, like those who formed the tight knot of intellectual agitation called "Canada First," viewed it as a new nationality. Still others saw it as the first step to the manifest destiny of a united North America.

But it would be wrong to suggest that Canadians were rampant visionaries. What visions there were — the beckoning west for example — were less the province of poets than of politicos and profiteers. Most ordinary Canadians would spend their days after Confederation as they had before — grappling with the physical dimensions of an unruly climate and, as one observer put it so well, "too much geography." The physical challenges would make Canada a difficult place to tame; it defied easy transportation and communication and the rhythm of the seasons would determine much of its economy, its society, and its outlook. Canada eventually might become more than a geographical expression, but it would always, in some fashion, be the sum of its geographies.

Saint John, New Brunswick: c. 1875. Photographed by J. McClure & Co. (NBM).

Saint John, with a population of thirty thousand in 1867, its heyday, was the fourth largest ship-owning port in the world. An ice-free Atlantic sea-port, Saint John was the home of wind, wood, and sail *par excellence* — "the town that timber built." Vast quantities of New Brunswick wood left the port in the years before the great fire of 1877 and before Baltic timber gradually began to dominate European requirements. This fine photograph of King Street shows the civility of age and maritime prosperity in the cobbled gutters, wrought-iron balconies, and mixed brick and clapboard frontages.

Toronto had long shucked its "Muddy York" epithet by 1867. Although it had less than half Montreal's age and scarcely half its population, Toronto was equally mercantile and looked to the opening of the Canadian west to grab the North-West trade from Montreal. This early summer morning scene on King Street East shows none of the railroad boosterism or the commercial banking structures which were so typical of the city. Rather Toronto appears with all the trappings of a large market town — substantial retail stores and services, respectable three- and four-storey frontages, gas lighting, wide plank sidewalks, and even a street gutter.

Toronto, Ontario: 1867 (OA).

Halifax, Nova Scotia: 1862. Photographed by Parish & Co. (PANS Acc. 5222).

There's a touch of Sir John A. Macdonald in the weather-beaten face of this dour Nova Scotian postman. Jock Craig was seventy-two years old when he had his portrait taken in Halifax; he lived until he was eighty-four, a very good age for any man in the nineteenth century. Fifty-four of those years were spent working for the post office. Canada's first post office was opened in Halifax in 1754, when that city's citizens began to use the mail packetships which put in on their voyages between Britain and the New England colonies. The following year the British General Post Office established Halifax as an official stop on the Imperial postal network.

In 1867, Quebec, from the Indian *Ké-bec*, meaning "the point at which the river narrows," was a bustling seaport of fifty-five thousand people crammed into this ancient lower town flavoured with a distinctly mercantile air. Immediately above, on the heights, rose the more spacious upper town surrounding the parliament buildings, the old governor's palace (the Chateau St. Louis), and Laval University. Higher still lay the Citadel guarding the river approach. Quebec, to most immigrants and visitors, was the first landfall in North America and the least like any other North American city they would encounter. Its mixture of English, Irish, Scottish, and French had produced a stone city of splendour and vigour. From one angle it could look like a Norman town, from another for all the world as if it should be on the banks of the Clyde. The large amount of shipping of various kinds stacked at its numerous quays or lying off in the river reveals the commercial importance of the place. Some visitors were enraptured, others complained that it was too self-aggrandising. Anthony Trollope, the novelist, had a more straightforward complaint: he found the walkways were "intolerably bad" and a major street he considered "more like the bottom of a filthy ditch." His conclusion: "Had Quebec in Wolfe's time been as it is now, Wolfe would have stuck in the mud between the river and the rock...."

Quebec City, Quebec: c. 1867 (OA/S-1146).

The fountains and lamps of these formal Victorian gardens in Hamilton suggest something of the pretensions to urban elegance in this important railroad and manufacturing community on the edge of the Niagara Peninsula. Known later as "the Birmingham of Canada," Hamilton's largely working-class population earned their living from hard stint in factories and workshops. This photograph of the Gore Park district in the late 1860s provides a nice contrast between a market town character on one side of the street and the more functional and industrial urban façades on the other.

Hamilton, Ontario: c. 1867 (PAC/C-8166).

Woodstock, Canada West (Ontario): c. 1865 (OA Acc. 12826-3).

This photograph of Woodstock, Canada West, needs only a flag on its tapering pole to complete the picture of a western Ontario agricultural station stop. The rich lands surrounding this sleepy town on the railroad that linked ports on the American border and Lake Huron, held farming communities which prospered mightily under "Clear Grit" politics.

In the village of Speedside, near Guelph, the students of the Reverend Enoch Barker's shorthand class pose, pencils poised, for the camera. This serious, purposeful group would find that their small class, taught by the Presbyterian minister of their village, was an important entry to a burgeoning bureaucracy in a confederated Canada. Not only were businesses in urgent need of secretarial and clerical staff, a new federal system of government added to the existing provincial authorities and offered ready employment — even in the days before typewriters. The women are standing, no doubt because of the difficulty of sitting comfortably around so small a table in crinolined skirts. At least two of the seated men show a fine disregard for their footwear, dusty from trudging dirt roads, in contrast to their well-tailored and carefully groomed upper halves.

Speedside, Eramosa Township, Canada West (Ontario): c. 1860 (UCC).

The wide sidewalks at Goderich, a town settled by the Canada Company at the western end of the great Huron tract, were of broad, sturdy planks. Goderich was built in the 1820s in an unusual octagon plan around a central circle. The town was both elegant and spacious, befitting the richness of its agricultural hinterland, but the rail terminal from London, Woodstock, Brantford, and points east to Toronto never worked to full advantage because the harbour at Goderich continually silted up. The soldier outside this hardware store would have been a familiar figure in many Canadian communities before the British army pulled out in 1870-1871, though it is possible that this uniformed figure may have been with the local militia. A sign for coal oil brings to mind that the inventor of kerosene, Abraham Geiser, came from Petrolia in Lambton County a few miles south of Goderich. Coal oil became a crucial commodity for interior lighting in the years between the wax candle and gas.

Judging from the thicket of stumps surrounding them, the men and horses in this somewhat damaged photograph of a stump-pulling contraption were in fine form. This elaborate and cumbersome triangle of chains and pulleys was oddly mobile and was plainly an attraction in a land as heavily forested as eastern Canada. Land clearance was the bane of any settler's existence, especially in southern Ontario and particularly by Confederation when the easiest, most accessible land had all been taken.

Ontario: early 1860s (OA/S-7849).

Goderich, Ontario: c. 1867 (OA/S-4747).

Quebec City, Quebec: 1872.
Photographed by Notman Studio (NPA 76,319-I).

Two photographs of the extensive timber coves along the St. Lawrence River indicate that timber exporting was still the lifeblood of the colonies' economies. The great timber ships were specially designed to allow the passage of massive squared timbers through their bows. Both these photographs bear vivid witness to the skills and the endurance of the labour force of the timber trade, which combined sheer manual power with the forces of water and wind in conditions far more taxing than these fine Notman views suggest.

Quebec City, Quebec: 1872. Photographed by Notman Studio (NPA 76,312-I).

Ottawa, Ontario: 1872. Photographed by Notman Studio (NPA 78,911-I).

Ottawa, the capital city of the new nation, was much smaller than Montreal, Toronto, Saint John, or Quebec — about sixteen thousand people. Only ten years previously it had been a brawling lumbering community on the Ottawa River, known as Bytown. The Rideau Canal had been started in 1826 at this location by Colonel John By of the Royal Engineers when Britain had felt it necessary to cut a passage from Ottawa to Lake Ontario at Kingston so that gunboats would have an alternative route to the St. Lawrence, which was too close to the American shore. By 1867 the Canal, whose locks can be seen in the cleft between the twin spires of the Cathedral and the unfinished Parliament buildings, had fallen into disuse. Not so the Ottawa River, along which passed the flourishing lumber trade. These barges are actually loading dressed planking, but the river was often a torrent of tumbling logs, corralled into huge rafts.

On the Red River Expedition: 1870. Photographed by J. H. Davis (GA 2050-1).

Far beyond the timber reaches of the St. Lawrence and the Ottawa rivers, beyond even the excruciatingly difficult colonization tracks northwest of the towns and farms of southern and western Ontario, lay the Prairies — the home of Indians, Métis, and employees of the Hudson's Bay Company.

In 1870, a postage-stamp-sized western province called Manitoba was proclaimed at Winnipeg. By then the Hudson's Bay Company had come to terms with the Macdonald administration in Ottawa and withdrawn from the enormous expanse of land it had controlled since its first fur-trading charter had been granted two centuries before. All the lands westwards to the Rocky Mountains — the North-West Territories — became an open invitation to eastern commercial enterprise and the goal of what would soon be one of the world's most extensive emigrations.

The probable impact of increased contact with the east was not lost upon the Métis population of Red River, who gathered behind a prophet of Métis nationhood, Louis Riel, and eventually took with armed force whatever local authority they might. Skirmishes with Hudson's Bay Company officials and government land surveyors culminated in the foolish execution by the Métis of Thomas Scott, an Ontario Protestant. Ottawa ordered a military expedition west to quell any disturbance. The force, led by Sir Garnet Wolseley and made up of regulars and militia such as this group from the Ontario Rifles, travelled by land to Collingwood on Georgian Bay and by water across Lake Superior to Fort William. But the worst stretch, for anyone less skilled than a fur-trade voyageur, was still to come — on the Davis Trail over rock and through forest to Winnipeg. Wolseley nevertheless brought his men and guns through to find that affairs had quietened down, the Métis had dispersed, and Riel had gone to the United States.

A rough-and-tumble Vancouver Island coal-mining community, Nanaimo was barely fifteen years old when this photograph was taken. The "bastion" of the Hudson's Bay Company post is visible at the far right — a symbol of the British commercial presence on the Pacific coast.

Coal later attracted "robber baron" capitalists like Sir James Dunsmuir whose exploitation of British Columbia's natural resources was second to none in production and in profit. British Columbia at Confederation was completely cut off from the government, the settled lands, and cities of Canada. All land communication with the east was made through the United States until the railway and telegraph got through the Rocky Mountains in the 1880s; federation, as far as British Columbia was concerned, was merely a paper arrangement.

Nanaimo, British Columbia: 1867 (VPL 6381).

Boston Bar, British Columbia, was the golden gateway on the Fraser River through which passed hordes of hopeful men in wagons similar to the high-sided covered wagons in this photography by Robert Maynard. The gold rush of the 1860s attracted thousands of prospectors to the Cariboo Trail northwards through the Fraser Canyon — many of them Americans from the New England states. This photograph was taken at least ten years after the rush; the picket fence along the road indicates a more settled existence. Clearly, however, the heavy, high-axled wagons pulled by oxen were still needed to ford rivers and cross creeks.

The road through Boston Bar was part of the northern trail to the interior goldfields after 1861 and was created by military and civilian engineers. Much of the road had to be blasted through solid rock.

Boston Bar, British Columbia: c. 1866 (CVA 3-25).

The boisterous, boom-time, shanty look of the famous gold "town" of Barkerville shows superbly what prospects of new-found wealth could do. Mountainsides were roughly cleared and the timber used to throw up a community with appropriate services — coffee saloon, restaurant, and bakery. The main street was no more than twenty feet wide, and, judging by the raised boardwalks, it must have been a quagmire of mud when it rained. The Cariboo rush was short-lived, but Barkerville, Richfield, and Camerontown continued to prosper after the peak was over. It was reported that nearly $20 million in gold was taken out of the mountain creeks in the 1860s. Barkerville was completely destroyed by fire in 1868 (in an hour and a half) but was rebuilt almost immediately by the British Columbia government.

Barkerville, British Columbia: c. 1867 (VPL 8637).

Cariboo Trail, British Columbia: c. 1866
(PABC/A-347).

Camels were brought into British Columbia in 1862 to help out on the Cariboo mule trains running between Port Douglas and Lillooet. It was fondly thought, mostly by their sponsor Frank Laumeister, that they would be an asset to moving supplies, but, in fact, their soft feet proved no match for the rocky British Columbia trails and the ubiquitous mules would not accept the camels' scent. They stayed in business for almost a year and then, amidst lawsuits for their owners, were turned loose in the Thompson valley where they terrorized mules, horses, and not a few surprised settlers. The last one died in 1905.

Fredericton, New Brunswick: c. 1875
(PANB/T-291).

A winter scene in Fredericton shows horse-drawn sledges of hay and wood passing through the market square — plus some intricate architectural details. The blankets draped over the patient horses seem to confirm the quiet inactivity of this mid-morning gathering.

Hochelaga, Quebec: 1870. Photographed by Notman Studio (NPA 43, 925-I).

The granting of the British North America Act and the declaration of relative independence which it brought to Canada meant, too, the return of British forces to England. Canada had seen constant evidence of a British military presence since the fall of Quebec in 1759, but by March 1869 advertisements for sale of cavalry and artillery horses were appearing in Quebec City and Montreal newspapers. The artillery unit shown in this Notman photograph at Hochelaga was in its last winter's exercises in Canada on a bank overlooking the frozen St. Lawrence, its cannon movable only on sleighs. By November 1871 the last troops had embarked at Quebec City and Canadians were left in the hands of militia and local police units. On St. Helen's Island at Montreal, long a military encampment, the retreating army left to the fledgling militia a School of Gunnery.

Ottawa, Ontario: 1875. Photographed by William J. Topley (PAC/C-2227).

When William Notman, the highly prolific and famous Montreal photographer, opened a studio in Ottawa in 1868, he sent William Topley to manage it. Topley began to gain a reputation as a portrait and scenic photographer, and, in 1875, bought the Ottawa studio from Notman, keeping the name for business reasons. Three years later he was appointed Official Photographer to Princess Louise, wife of the Marquess of Lorne. During the next four decades, Topley took thousands of portraits, many under government contract, and issued popular "Views of the Dominion" for sale. Apart from his photographic legacy, the name of Topley has been preserved in a small British Columbia community, named by the Grand Trunk Pacific Railway, enamoured with his commissioned views taken along its route.

TWO

Promises of Youth

The years from Confederation to the turn of the century were a time of "nation-building." The constitutional difficulties of the old central colony of Canada were largely overcome by the creation of the new federal scheme. The land and the government were extended and united by a process frequently labelled "defensive expansionism." The key to state involvement in the claiming and colonizing of the west was to be the establishment of a national rail link. The Canadian Pacific Railway, a clumsy, expensive colossus, turned out to be as much national nightmare as national dream, but it was the vision of Prime Minister Sir John A. Macdonald to buckle the country together in a steel embrace. He succeeded, by hook and by no little amount of crook, but the blessings that were to flow from his vaunted "National Policy" were slow in coming.

Macdonald's recipe for prosperity was threefold: establish the life-sustaining railway; people the west with a massive push of settlers; and finally, establish a tariff wall to nurture nascent Canadian industries and protect what he hoped would be burgeoning markets. The Maritimes as well as the west were to share in the bounty and benefits from this truly "national" coast-to-coast program. It misfired badly during the years of Tory ascendancy, and, ironically, only worked well for the Liberals, who came to power under Wilfrid Laurier in 1896.

One of the prime problems facing Macdonald's master plan was a global depression which lasted for almost two decades and which seriously warped economic expansion from 1873 on. Additionally, the Canadian west was not viewed by many as the "last best west" until the 1890s — after American opportunities faded. Nor did the National Policy bring a munificent commercial life since the western markets failed to develop on any substantial scale. Indeed, the scheme was viewed by many as simply another example of "Ontario Imperialism" — an outlook which made western farmers angry about the price of farm machinery and Maritimers equally disgruntled because, despite the promises of Ottawa, the world continued to pass them by. In short, the National Policy achieved the opposite of what was intended. In some ways it even highlighted regional inequities. Besides, it produced some ruder ironies. High tariffs, designed to be a spur to an independent Canadian economic development, caused

American firms to establish branch plants on the Canadian side of the border where they would not be tainted by tariff considerations. Decisions, of course, would be made in the American home office. Canadians, incidentally, were wildly enthusiastic about attracting these American plants to their communities; every possible incentive — from tax-reductions to outright bribes — was made to lure, coerce, cajole, and otherwise persuade the foreign capitalists to come.

Westward expansion claimed a human toll as well. A collision of cultures occurred in the wake of the Hudson's Bay Company's retreat from its vast chartered territories in 1869 and the subsequent clumsy intrusion of Canadian claims. If Louis Riel, the leader of the disgruntled Métis of Manitoba had gone no further than his scrappy defense of Métis rights at Red River he might have been elevated to the status of a Father of Confederation. The execution of the loud-mouthed Ontario Protestant bigot Thomas Scott, however, enraged Orange Ontario and ensured that although the Canadian west might be settled in an orderly manner it would not be without bloodshed.

Manitoba became a province in 1870; British Columbia, with the promise of the completion of the railway, a year later. Prince Edward Island, awash with railway debts, in 1873 decided to join the project that had been born almost a decade before in the Island's capital, Charlottetown.

It was the land between Manitoba and British Columbia that proved to be Confederation's battleground. The Canadian west was not to be tamed like the American west — it was not a land of personal vices and virtue, of liberty and striving individualism. Rather it was settled and suppressed neither by ploughshares nor by six-guns, but by large, frequently unwieldy, and insensitive organizations, the most clumsy and inept of which was doubtless the federal government itself.

Railroad companies, the Mounted Police, land companies, provincial governments, boundary commissioners, and, in the final analysis, the army, superintended settlement. The second Riel Rebellion in 1885, led by a now-crazed self-styled prairie prophet with a messianic vision, was really the last stand of a people whose economic livelihood and birthright were being swept away. The fact that a majority of them spoke French and were Catholic gave the event a national scope that would have been lacking had Riel been merely a deranged Englishman. His death by hanging reopened all the wounds so slightly salved by the Confederation compact. Quebec, under the leadership of Honoré Mercier, once more became actively nationalistic, and the whole cultural and social future of the country became uneasy. Quebec was not alone in straining the fabric: Premier Oliver Mowat's Ontario was the most aggressive pursuer of provincial rights and the frequent victor at well-publicized judicial duels at the country's highest court — outside the country, of course — the Judicial Committee of the Imperial Privy Council in London.

There were other divisive forces as the century moved to its close. Canadians were invited to consider several possible futures: Macdonald's virtuous Canadian nationality tinged with British values was one; full-fledged Imperial federation was another; and a third was the idea of continental union with the United States ("natural geography," some called it). The very best kind of balancing act would be necessary for the country to steer a survival course through to the end of the century. The pilot, Laurier, would come aboard at just the right time — in the election of 1896.

This ceremonial occasion, the induction of the new Governor General of Canada, was hardly unusual in a country just emerging from colonial government; nor was this kind of photograph uncommon. It is known as a "composite" and was a popular device for flattering egos and making money. Each person was photographed separately and superimposed on a background scene — in this case the Assembly Rooms in Province House, Halifax, painted by Henry Sandham in 1879. The new Governor General was a Scottish lord, Sir John Douglas Sutherland Campbell, the Marquess of Lorne, whose royal wife, the Princess Louise, a daughter of Queen Victoria, saw Canada wholly in terms of scenery. Her first name was bestowed by Canadian Pacific on Lake Louise, a glacial lake of arresting tranquility and great splendour in the Rocky Mountains of western Alberta. Her third name, Alberta, was given by her husband to part of the Athabasca district of the North-West Territories following his romantic tour of the west in 1881. He travelled by rail to Portage La Prairie (then the end of steel) and on horseback to the Rockies. Many of Lorne's sketches of Canada were good enough to find publication in the *Illustrated London News*. A volume of them, entitled *Canadian Pictures*, did much to popularize the "romantic" Canadian west.

Halifax, Nova Scotia: 1878.
Photographed by Notman Studio (PANS Acc. 7097).

33

The great ice-floes jammed in the foreground of this view of Montreal across the St. Lawrence, probably taken from St. Helen's Island, quickly remind the viewer that the city is inaccessible for a third of the year. This commercially melancholy fact had quite early encouraged the creation of a rail outlet to the sea. By 1851, the St. Lawrence and Atlantic Railway had got up steam and joined Montreal, and the "eastern townships" through which it passed, to ships and markets at Portland, Maine.

Montreal, Quebec: 1870. Photographed by Notman Studio (NPA/MP 301).

Discovery Bay, North-West Territories: 1876 (PAC/C-10866).

A lovely scene in the North-West Territories published in George Strong Nares's description of his Arctic Expedition of 1875-1876, *Narrative of a Voyage to the Polar Sea*. The Nares expedition was the last of a number of major British explorations to the Arctic archipelago prior to Canada assuming sovereignty in the far north in September 1880. European and British explorers had penetrated the Arctic seas in search of an elusive Northwest Passage to the Orient since the mid-sixteenth century. Fur traders, Hudson's Bay Company employees, and soldiers had pushed north by river and trail for most of the nineteenth century and an amazing amount was published about the region. Yet, to a Canadian in the southern populated strip along the St. Lawrence and the lower lakes, the experiences and observations recorded by the likes of George Nares read like fiction. Indeed, it was at least another forty years after the Canadian assumption of sovereignty in 1880 before the Arctic really seemed part of Canada, and then it was largely through the adventurous exploits of bush pilots.

All else in Canada seemed to pale into insignificance beside the central policies of Sir John A. Macdonald's administration. His declared intent was to open up the west to settlement — under tight Ottawa control. The new province of Manitoba needed a more substantial link to Ontario than an impossible trail through forest and lake. British Columbia's distant cry for contact with its new federal colleagues could not be ignored for long. Even more urgent was the need to establish a stronger Canadian presence in the vast southern Prairies, where Americans were the most frequent visitors to the hunting lands of the Cree and the Blackfoot bands. A visible definition and occupation of these lands by Canadians from the east would curb American penetration and pave the way for the architect of Canadian unity — a coast-to-coast railroad. The ox-wagons and men of the 1872-1874 Northwest Boundary Commission, seen here at Dead Horse Creek, were the frontrunners of a London-Montreal-Toronto commercial axis eagerly fuelled by nationalist aspirations in Ottawa. Records of the Commission note that progress was twice interrupted while massive herds of buffalo, hundreds of animals deep, moved across the open Prairie.

Dead Horse Creek, North-West Territories: 1873 (PAM Boundary Commission 108).

While the Boundary Commission completed its survey on the Prairies, British Columbia's pressures on Ottawa for a railway and a telegraph line grew. Yet Ottawa, and eastern businessmen in general, were not eager to see virtue in satisfying British Columbia's demands unless there was some prospect of profit to justify the staggering capital outlay. Ottawa was obliged to tell her western colleague to be patient and not to expect a railway much before 1890. This ceremonial arch in Victoria, prepared for Governor General Lord Dufferin's visit to the province in 1876 (via the United States of course), stated British Columbia's views in no short measure. "Carnarvon Terms" referred to British Colonial Secretary Carnarvon's promise under a compromise arrangement with Ottawa that Vancouver Island would at least get an Esquimault-Nanaimo railway. Naturally, Lord Dufferin refused to pass under this slogan which attempted to blackmail the Canadian government.

Victoria, British Columbia: 1876
(PABC/D-1306).

Oxen, drovers, and greasers like these on this corduroy road on the site of the future city of Vancouver were common sights on the west coast. Great firs were axed and dragged out of the dense forest on slippery transverse logs by ox teams. The work was terribly hard and inefficient but inescapably necessary for both clearance and construction — not least, railway construction.

Vancouver, British Columbia: c. 1880 (PABC/F-444).

The continental railway contract between Macdonald's government and the already wealthy Canadian Pacific Company was signed in 1880 amidst a storm of opposition over its liberal terms. Canadian Pacific agreed to join the government in building the line in various sections and subsequently to operate the whole length. In some respects, the Company did not have as easy a time of it as might be thought, either in construction or in raising capital. Nevertheless, the freight monopolies (especially on wheat shipments east from Winnipeg) were considerable, and the basic gift to the Company of $25 million and 25 million acres of land between Callander in northern Ontario, and Banff, on the eastern edge of the Rockies, was the largest "deal" negotiated between a government and a private business since England approved the Hudson's Bay Company Charter of 1670. A small but pointed western voice summed up the eastern contract at Christmas 1880 — the CP deal was made by men, who, as one contemporary observer noted, "think the sun rises in Halifax, shines all day straight over Montreal and Ottawa, and sets in Toronto — whose hymn book is the praise of England and whose Bible is the example of the United States."

One example of the difficulties of construction in the Rockies and the coastal cordillera is seen in this photograph of a wooden horseshoe trestle, taken about ten years after its completion. The perky passenger train snorting mid-way across the trestle and the company men casually teetering on the edging beams belie the labour and skill which went into such work.

British Columbia: c. 1890 (CP 12576).

Chinese had sojourned in British Columbia since the 1850s gold rush, intending to seek their fortunes and return to China. Few did so, and, after 1881, Chinese men (not families) were deliberately recruited to self-policing gangs to work on building the mountainous sections of the transcontinental railway. Some twelve hundred cabins, such as these photographed near Keefers, British Columbia, housed Chinese rail workers who hewed ties by hand from the forests.

Keefers, British Columbia: 1885 (PABC/D-8745).

Winnipeg, Manitoba: 1878 (SPL).

Canadian Pacific's later claim to be "the world's most complete transportation system" is seen in embryo in this 1878 photograph of the prestige eastern locomotive, the "Countess of Dufferin," arriving by barge from Minnesota to begin work on lines south and west of Winnipeg. The same year, CPR's St. Paul to Winnipeg line opened and thousands of Ontario families took the rib-shaking journey north to begin farmsteads along the prairie railbed.

Rogers Pass, British Columbia: c. 1890s (CP/M-1282).

This scene in the Rogers Pass roundhouse on the morning after a hard freeze reveals some of the perennial problems of railway operation in Canada. The Rogers Pass, first uncovered in 1864, was tackled for the railway in 1882 by Major A. B. Rogers, a wiry New Englander who had been recently made Engineer of CP's Mountain Division. It was named after him the following year by Sandford Fleming and the Reverend George Grant of Queen's University when Rogers took them both through this beautiful pass. This moment of exaltation for the three men also established the first meeting of the Canadian Alpine Club — Fleming as President, Grant as Secretary, and Rogers as first honorary member.

Vancouver, British Columbia: 1887
(CP 25746).

Canada's very first trans-continental train — nine cars long: two baggage, two sleepers, two First Class, two Second Class, and one dining — left Montreal at 10:30 p.m. on June 28, 1886, and clanked into Port Moody — twenty miles east of Vancouver — at noon on Sunday July 4, 1886, five years earlier than the CPR contract of 1880 had anticipated. It was the beginning of a new era. As the first trains were arriving in Vancouver, steamers were leaving the Orient bound for Canada and for Europe. "Occident greets Orient" shouts the streamer over this train. Vancouver was scarcely five years old, barely chopped from the surrounding forest and very rough and ready. This famous photograph, apart from recording the railway achievement, shows plainly how ripe for fire the young settlement was.

With all the delicacy of a watercolourist, the photographer of this West Coast Indian and his children has captured despair. It is believed that this particular Indian was the first to be employed by rail contractors and was photographed in the mists of uncertainty just after losing his job when the CPR was completed. The railway changed the face of the west irrevocably, but most of all it brought about the destruction of Indian freedoms — sweeping away the comfortable balanced relationships most bands had developed with the Hudson's Bay Company. The British Columbia Indian had different issues to cope with than his prairie brothers, but the surge of white contact and settlement which came with the railway almost immediately brought all Indians up against it.

Near Vancouver, British Columbia: c. 1886 (PABC/D-8806).

Vancouver, British Columbia: c. 1890 (CP 6678).

Real estate bonanzas had sprung up all along the rail line west of Winnipeg. Nowhere did land values boom so rapidly as in Vancouver, where Canadian Pacific was the largest landholder. Within ten years of their accumulation, CP lots had risen from sale prices of twelve hundred dollars to as high as ten to twenty thousand dollars. In one year alone, the coming of rail raised nearby lots two hundred per cent. Mr. W. Horne clearly lost no time when he set up his office in a hollow fir and posed suitably for the camera. Horne may have been working in the future Shaughnessy district as a Canadian Pacific agent.

43

Yale, British Columbia, was a major focus in the Cariboo gold rush of the 1860s, and the town swiftly became the head of navigation for river boats. In 1868, under the leadership of the Victoria *Colonist*'s publisher Amor de Cosmos Smith, it became the venue of a convention of twenty-six delegates who decided to press Ottawa for "some organised and systematic mode of obtaining admission to the Dominion of Canada." This view of the town from across the Fraser River (with the steamer *William Irving* at the landing) was taken after the place was rebuilt following devastating fires in 1880 and 1881. By 1882 Yale had once more resumed its bustling communications status as the rendezvous of almost ten thousand men engaged on railway construction.

Yale, British Columbia: late 1880s (CVA 3-4).

Gull Lake, North-West Territories: c. 1886 (SAB/RB-3195).

There can be little pride in the heaps of whitened buffalo bones waiting to be shipped east to be ground into fertilizer. Such gruesome piles were not uncommon at rail sidings on the Prairies in the 1880s, for agriculture could not prosper on the plains until they were cleared of the gigantic buffalo herds. Although Mounted Police detachments on the southern grasslands in the 1870s had met large herds of buffalo, by 1885 an incredibly ferocious American slaughter had wiped out millions of animals, and purposefully set grass fires prevented even a residual number from turning north to Canada, where, in any case, Canadian settlers would have completed the elimination within a few years. The virtual extinction of the buffalo herds had reasons both complex and various, not least of which were the repeater rifle and a voracious industrial demand for leather drive-belts, but there is little doubt that in Canada the building of the railway and its accompanying settlement facilitated the devastation. Not a few settlers made a little money by gathering up the bleached bones and rotting carcasses of the buffalo.

The passing of the buffalo greatly damaged relations between Ottawa and the western Indian bands. In theory, Canadian policy was to bring about Indian economic self-sufficiency — in effect, to convert them overnight from ten thousand years of nomadic hunting to reserve-based farming. It couldn't be done. The Indian's traditional life on the Prairies was ruined within a decade. To the visiting Toronto writer and historian, Goldwin Smith, on a trip west of Manitoba in 1884, Canada's Indian was "manifestly doomed. There he sits in the sun gazing listlessly at the railway train." The Blackfoot warrior romantically portrayed in this Notman photograph was a rapidly passing figure. The Indian as noble savage was far from reality but such a presentation, exquisitely contrived, sold very well in the urban east and in Europe.

Neither Indians nor Métis nor, indeed, the slightly higher number of whites in Assiniboia, Saskatchewan, and Alberta districts had any political representation in Ottawa. The east was seen to be distant and uncaring, a view not dissimilar from that of the easterners towards *their* government in Westminster fifty years before. To the *Prince Albert Times*, the regional council of the North-West Territories, seen here meeting in Regina in 1884, was a "wretched farce." To be fair, the fourteen-member Council had warned Ottawa twice (in 1883 and 1884) of brewing unrest amongst the Métis, but the Council was without power or authority to do much about it and Ottawa took events seriously only when a rebellion had broken out.

Regina, North-West Territories: 1884 (PAM/N-1419).

South Alberta District, North-West Territories: c. 1880s. Photographed by Notman Studio (NPA 2159).

46

The Dominion's reaction to another Métis uprising, the second Riel Rebellion, in 1885, was eminently predictable — armed force. The North-West Mounted Police had been working for a decade right across the Prairies, but clearly they were incapable of coping alone with widespread unrest, especially if Indian bands rallied behind the Métis' desperate cause. Canadian militiamen were despatched to the North-West Territories, travelling in relative speed and comfort on the train. The Rebellion was suppressed rapidly, Riel surrendering to imprisonment with great calm while his comrade, Gabriel Dumont, escaped to Montana. Louis Riel was hanged after a famous, much publicized trial in Regina. He is sometimes spoken of as the "Father of Manitoba," a fair accolade for his accomplishments in 1870, but it is generally accepted that his religious obsessions and unbalanced mental state prevented any real chances of political or military success in 1885.

Beside a detachment water cart on Pile O'Bones Creek, one of the North-West Mounted Police units on the Prairies drill. The barracks in the middle and distant reaches of the photograph are on the site of what would later be the Royal Canadian Mounted Police headquarters to the west of the city of Regina.

Regina, North-West Territories: 1885 (CP 3740).

A sentry box of sorts during the North-West Rebellion —
set on what looks more like the South African veldt than
the Canadian Prairie. This photograph is one of several
taken by a Canadian artillery captain, S. Frank Peters,
who packed a camera along with his Gatling gun at the
Battle of Batoche.

Probably Prince Albert, North-West
Territories: 1885. Photographed by Frank
Peters (PAC Peters Album 1, p.48).

Amongst supply boxes and wagons, Dominion soldiers collapse in sleep in a
rough trench at Batoche. Again, this is a Peters photograph.

Batoche, North-West Territories: 1885
(*Ibid.*).

48

Men of the Winnipeg Field Battery relax in a special rail car taking Louis Riel from Swift Current to Regina to stand trial for treason, May 22, 1885. Back home in the east all five thousand soldiers involved in the Rebellion were rapturously received as heroes though they had never stood against more than three hundred Métis at any one time!

Photographed by O. B. Buell (GA/NA-3205-5).

Duck Lake, North-West Territories: 1891
(US/Mss c550/2/3-16 XVI).

Riel's dream for a different sort of prairie state was never realised, as this photo of the Third Annual Sports Day at Duck Lake so plainly shows. This sedate meet is set against a prairie landscape, but all its ingredients are imported. There is a tinge of Victorian elegance to the occasion as this pioneer community parades before itself. The natty gentleman on the velocipede is a federal Indian agent, W. B. Cameron, later author of *Blood Red the Sun*. One week earlier, in Ottawa, Canada's first prime minister, Sir John A. Macdonald, had died.

Banff, North-West Territories: 1886. Photographed by A. B. Thom (ACR/NA66-1241).

For some people at least, the trans-continental railway brought new recreational delights. The possibilities of mountaineering, skiing, or just languishing in clear, sparkling air appealed hugely to easterners — Canadians, Americans, and increasingly Europeans too — some of whom were willing even to foresake Switzerland and Austria for the Rockies. Banff was an exquisite spot on the eastern edge of the mountains. Canadian Pacific very early began a timber lodge there and Lord Strathcona successfully pressed for the Banff area to become Canada's first national park in 1887. The Grand View Bath House at Banff, served by a horse cab, was typical of the attractions which sprang up. Liquor may not have been publicly available, but billiards were, as well as three fairly fancy types of body massage.

The Quebec Interprovincial Conference, its delegates captured in an official photograph — Oliver Mowat of Ontario in the place of honour as Chairman — was not attended by the federal government. British Columbia and Prince Edward Island also declined to attend, leaving the four original provinces and Manitoba to review the fabric of Confederation twenty years on. As the first of its kind in Canada, this eight-day gathering inevitably discussed exactly those same issues which plague the country nearly one hundred years later — how to sidestep federal policies which were not harmonious with provincial perceptions; the boundaries of federal-provincial jurisdiction; and the best formula for fixing provincial subsidies.

Quebec City, Quebec: 1887.
Photographed by M. A. Montmini
(OA/L-15).

Toronto, Ontario: 1892 (UTA).

The seat of Mowat's government was the WASP fortress of Toronto — a bustling metropolis of two hundred thousand souls. Macdonald's National Policy had greatly encouraged the city's entreprenurial and industrial capacity, as could plainly be seen down amongst the wharves and railway depots at the lakefront. From the tower of the university's oldest college, however, just west of the provincial legislature, only traces of the factory smokestacks could be glimpsed, and smug, Tory Toronto takes on the airs and appearance of an English university city, far older than its hundred years.

In the decade following Confederation Saint John, unhappily, lost its eminence as a gracious city and a thriving eastern seaboard port. The devastating fire of June 20, 1877, levelled the entire business district — 1,612 houses were destroyed, ten miles of streets ravaged, $27 million calculated in dollar losses, and fifteen thousand residents made homeless. Even ships, such as these in this Notman Studio photograph, were burnt at their wharves. Relief flowed in from all over the world. However, Saint John would never recover fully from this great scourge of North American cities, though clearly, changing economic circumstances also took their toll. Saint John, despite its ice-free port, would be unable to compete with the western axis achieved by the completion of the CPR.

Saint John, New Brunswick: 1877.
Photographed by Notman Studio (NBM).

Montreal, Quebec: 1884. Photographed by Notman Studio (NPA 73,328 - II).

This contrived photograph of a McGill University "anatomy" class backhandedly shows the impact which certain professional schools were making at the older universities. Sir William Osler, world-famous medical teacher, spent a large portion of his professional life at McGill (where his papers and library are now located) and, amongst various epithets and aphorisms which were eagerly gathered from his addresses and speeches, is one which few doctors have subsequently taken to heart — such are the temptations of professionalism. Observed Osler, "One of the first duties of the physician is to educate the masses not to take medicine."

In the late 1890s, a Labour Day Parade winds down the dirt and plank track of Cordova Street, Vancouver. The street is lined with a jumble of stores; the Hudson's Bay Company's turreted roof is in the distance on the right-hand side of the street and Bailey Bros. Stationery Store, which distributed photographs like this to people without cameras, is in the right forefront. The sight of a Labour Day Parade was not common, for British Columbia labour had been very slow to organise. The "company province" was held in the monopolistic vice of wealthy capitalists like the Dunsmuirs, who kept wages low, employed immigrant workers whenever possible, failed to develop satisfactory safety standards, and generally kept the government of the province in their pockets. By 1893, severe recessions in coal-mining, fishing, and lumbering along the west coast had sparked labour to organize, and Central Labour Councils in Nanaimo, Victoria, and Vancouver began making headway. Severe strikes took place in many industries across the country at the turn of the century — striking fishworkers in British Columbia were paralleled by coalminers in Glace Bay, Nova Scotia, and longshoremen in Montreal, Quebec. Canadian business, much of it financed by American capital, and often (as in the case of the Grand Trunk Railway) run by ruthless American capitalists violently opposed to unions, soon became a battlefield for American unions which saw an excellent opportunity to strengthen their bases in Canada and, regretfully, give a powerful challenge to the home-grown Canadian labour movement.

Vancouver, British Columbia: c. 1897 (CVA/STR. P.1).

Peter Elhatten's carriage works in Bathurst, New Brunswick, were typical of a host of small to middling-sized local industries involved in manufacturing almost every item of domestic needs during the nineteenth century. The market for horse-drawn carriages was soon to receive an irrevocable setback with the advent of the motor car, and, if adaptation was impossible, the likes of Elhatten would go under.

Bathurst, New Brunswick: 1893.
Photographed by Ole Larsen
(PANB/L-71).

Despite the new emphasis on the west and on wheat, eastern timber still flourished on the St. Lawrence and Ottawa rivers. Demand for pulp and paper products was growing around the world, and construction timber was eagerly awaited on the Prairies and in the American west. Two J. E. Livernois views of the old river settlement at Sillery, two miles west of Quebec City, show labour and productivity proceeding in traditional fashion in the mid-1890s. For long periods of every year, the working men still lived a lonely bunk-house existence in forests or on river rafts.

Sillery, Quebec: c. 1895. Photographed by J. E. Livernois (ANQ/N 1073-41 *and* ANQ/N 1173-89).

If a railway to the Pacific had eased some of the obstacles to communication across the Dominion in 1886, in some quarters of the old colonial lands the savageries of Canada's winter weather were still a hurdle to daily traffic. A provincial steam rail service may have been a successful lure to get Prince Edward Island into Confederation but it couldn't cope with the ice in Northumberland Strait between Cape Traverse and Cape Tormentine. An ice-breaker mail service run by the federal post office gave passengers the doubtful privilege of paying $2 a trip to haul the boat over the ice-floes. There were regular complaints to Ottawa, and an 1885 disaster in which several lives were lost speeded improvement, but the boats were used until a daily car ferry service was begun in 1917.

Northumberland Strait: c. 1899
(PAPEI 2320).

The lonely "sod-buster" existence of the first western pioneers was swiftly banished in many parts of the Prairies by powerful machines, imported from the east or more likely from American manufacturers. Steam threshing, seen here in Alberta in 1898, normally meant hiring the equipment (such as this, from Shackleton Brothers) to get the harvest processed. Often, the event was a social affair too, as Ernest Brown's carefully positioned camera has revealed.

Alberta: 1898. Photographed by Ernest Brown (PAA/B-273).

Edmonton, North-West Territories: 1895. Photographed by Ernest Brown (PAA/B-1890).

Another Ernest Brown photograph (from a glass plate negative, unfortunately cracked) captures the Edmonton detachment of the North-West Mounted Police in 1895. It had been twenty-one years since Ottawa had first sent out to the south Athabasca District a unit of professional police officers to act as protectors and facilitators of a new society. They had set up forts, encouraged farming, built and protected telegraph lines, enforced quarantine regulations, chased rustlers, calmed stockmen's fears about the CPR, fought in the North-West Rebellion, recruited tough young men looking for an adventurous career (one of whom was a son of Charles Dickens), composed and played songs, and danced at community balls: in short, they had become familiar figures of western life. Their soft, wide-brimmed headgear (forerunner of the modern Mountie hat) is far removed in this portrait from the pill-boxes and pith helmets of the early years. These men were confident and comfortable in an occupation they well understood.

Although this photograph looks like a Hollywood film still, it is, in fact, calf-branding time on the Woodward Brothers' Nicola Valley ranch in the interior of British Columbia about 1895. These fertile, lush grasslands gave rise to a provincial cattle industry of prodigious proportions.

Nicola Valley, British Columbia: c. 1895 (PABC/C-5954).

The Anglo-British Columbia Packing Company was founded in 1890 with British capital and it wiped out most small operations through concentration, price-fixing, and vertical integration, or control of all phases of the business. Chinese or Indian women made up most of the labour force. During the spring they made the cans on a machine unpleasantly referred to as "the Iron Chink." In 1902, the Anglo-British Columbian was amalgamated into the biggest firm of all in west coast fisheries — B. C. Packers.

Steveston, British Columbia: c. 1892
(CVA Indus. p.5).

Cumberland, British Columbia: c. 1892
(PABC/A-4531).

The Union Mine at Cumberland, British Columbia, was one of the worst examples of James Dunsmuir's industrial operations. This photograph shows the dreary existence of men living in wooden fire-traps hacked out of the forests and working in shafts without safety measures — always prone to explosive dust pockets and gases. Much of the radicalism of unions in British Columbia by the end of the century sprang from men who had suffered under "Dunsmuirism." Not surprisingly, when Dunsmuir became premier of the province in 1900, matters became critical, and strikes flourished, especially with the movement into the province of the American Western Federation of Miners. Dunsmuir's image was frequently burnt in effigy in response to statements such as "I can hire them if I like, and they can work if they like."

British Columbia: c. 1890 (VPL 19774).

Just to prove that lumber was not an eastern prerogative, the British Columbia forests produced logs sixty feet long and three feet square! A locomotive with flat cars proudly hauls "British Columbia Tooth Picks" awaiting shipment in the vessels ready at the wharves.

Emerson, Manitoba: 1897 (PAM Transpo. Boat - Assiniboine 1).

Emerson, Manitoba (named after the American essayist Ralph Waldo Emerson), began life as Hudson's Bay Company Fort Pembina. It became North-West Mounted Police Fort Dufferin and townsite in 1874, rising in population with the opening of the St. Paul–Winnipeg railroad in 1878. Ten years later the booster effect of this north-south line (Canadian Pacific's original money-spinner) was just as quickly squashed by the construction of the east-west continental line. By the time this photograph was taken in 1897, after a particularly savage spring flood on the Red River, Emerson had receded into quiet obscurity off the main traffic route. The river steamer, *Assiniboine*, seems to be on its way down the main street.

Montreal, Quebec: 1892 (CP 2729).

Considering that this photograph of an operating room in Montreal General Hospital was taken over thirty-five years after Joseph Lister and Louis Pasteur had discovered the causes of surgical infection, some astonishment might be expected. Apart from the clean white linens and cottons and the pinned-back hair, just about everything else leaves something to be desired — not least the dust-laden heating pipe and looping electricity cables.

Daisy Bell, an Indian woman, on the Fraser River, probably near Harrison Lake, British Columbia, 1895 (CVA In. p.42).

This studio portrait of Louis Riel's Métis companion, Gabriel Dumont, was taken when he was in his early sixties. Dumont was born in Assiniboia in 1830 and brought up surrounded by Indian warfare at Fort Pitt and Fort Garry. He became a good horseman and a crack rifle shot, but he soon realized that hunting and fishing alone could no longer properly support a family. After joining Riel in 1869, he worked as a trapper and a missionary guide for the Hudson's Bay Company, then bought a farm near Batoche and ran a ferry, known as Gabriel's Crossing, across the South Saskatchewan River. Following the defeat at Batoche in 1885, Dumont escaped to Montana where he was arrested briefly by American soldiers but released on presidential command. His wife, Madeleine, joined her husband in Lewiston, New York, some months after Batoche — and after Canadian troops had destroyed their farm — but she died early in 1886. Gabriel Dumont then joined Buffalo Bill Cody's "Wild West Show"; it is as a celebrity marksman that he is pictured here. He returned to Batoche after an amnesty was declared and died there in 1906.

Five Finger Rapids on the Yukon River, here being navigated by the steamer *White Horse*, was one of many hazardous sections on the six-hundred-mile water route to the Klondike from Lake Bennett, the headwaters of Yukon navigation. Whitehorse, at the lower end of White Horse Rapids, after 1899 became the head of navigation on the Yukon waterway and the terminus of the White Pass Railway, which came over the Chilkoot Pass from Skagway in Alaska.

The Klondike News—the Yukon's first newspaper—published its first issue at Dawson, North-West Territories, on April Fool's Day, 1898. For many of the tens of thousands who were lured to the "last North-West" in 1898 and 1899, this must have seemed like an awesome prophecy. The riches recorded by the likes of George Washington Cormack (after whom Cormacks is named) were beyond even the smell of most men. The gold rush proper had begun in the summer of 1897 when ships bearing the first Klondikers, with a million and a half dollars in gold, arrived in San Francisco. By the time the *News* appeared, thousands of fortune-seekers had found their way to the Yukon goldfields hoping to emulate the strikes which Cormack had made at Bonanza, Elwoods, and Gold Bottom.

67

A distinctly male gathering outside a Yukon outfitter on Cordova Street, Vancouver. The twelve mules bear commercial advertisements and not one person lacks some kind of hat. Although barely twenty years old, Vancouver clearly has urban aspirations — notice the street railway and the monumental façades. George E. Trorey's jewellery shop, next to Johnston & Kerfoot's, later became a part of the nationwide Henry Birks and Sons chain.

Vancouver, British Columbia: 1898 (CVA STR. p.336).

A no less busy or expectant, but nonetheless very different scene awaited the mule train prospectors at Dawson, North-West Territories — when and if they made it there. The Yukon Flyer Line advertised two fast steamers (appropriately named *Bonanza King* and *Eldorado*) to Vancouver and Seattle in ten days. E. A. Hegg's sunny view of Front Street with British and American flags bravely snapping, men perched on wheelbarrows, others making their way to the Casino, and even a woman with parasol and bustle, created a picture of great optimism. Wooden houses were creeping up the valley sides behind the main street. Dawson, soon known as the "Paris of the North," had something for everybody, although the more blatant of its prostitutes were moved across the river to Lousetown (or Klondike City, as it was more politely known). By the summer of 1898, Dawson was the largest town west of Winnipeg and north of Vancouver.

Dawson, North-West Territories: 1898.
Photographed by E. A. Hegg (UCC).

An avalanche — only one of the hazards of the Yukon, befell this man. That's probably a police officer standing by his head, and he is surrounded by men whose faces reveal hardships either suffered or expected. The worst avalanche in the Yukon took place on Palm Sunday, April 3, 1898, when sixty-three corpses had to be dug out of the Chilkoot Pass.

(YA 1328 Univ. of Wash.)

Two trail packers enjoy a quiet moment. A haircut cost $1.50 in Dawson in 1898 (YA 3683 Macbride MUS).

The Chilkoot Pass is perhaps the most familiar symbol of the Klondike. Photographs of men toiling up its southern slopes with pack-loads of seventy or more pounds during the severe winter of 1897-1898 have imprinted the craziness and hardship of the mad Yukon dash on most people's memories. E. A. Hegg, who hung his shingle in Dawson, took many of the most famous views. This one is from "the Scales," where Indian porters weighed packs before joining the seemingly never-ending line up the slope. Shown here is the Chilkoot Railroad and Transportation Company's aerial tramway cables which could carry up to four hundred pounds a time (at 7.5 cents per pound). It began operations in May 1898. At the top of the pass — at the Canadian border so to speak — a contingent of North-West Mounted Police stood guard to turn back any who hadn't a ton of food and supplies to last out many months at the fields — still some five hundred miles further on. It took a man as many as thirty trips, waiting in line each time, to bring up those supplies.

Chilkoot Pass, North-West Territories: 1898. Photographed by E. A. Hegg (PAC/C-14260).

Bonanza Creek, nearly twelve miles southwest of Dawson, was the site of the first discovery on August 17, 1896. The Mrs. G. I. Lowe in this photograph may well have been related to Richard Lowe, who worked with the Canadian government mining surveyor William Ogilvie, and who staked out claim number two at Bonanza. He worked the claim himself at an enormous profit.
If she is related to him, she clearly must not yet have taken part in Lowe's successes.

Bonanza Creek, North-West Territories: 1898. Photographed by E. A. Hegg (YA 2473 Univ. of Wash.).

Ernest Brown's camera collection, displayed by Brown in this cracked glass plate print, was second to none in the western Prairies by 1913. Brown, an Englishman from Middlesborough, moved to Alberta and established himself with William Mathers in Edmonton, later buying out the Mathers studio. His brushes with bankruptcy, fire, and the City of Edmonton did not prevent his surviving negatives from becoming the most important visual record of western Canada in the first two decades of the twentieth century.

Edmonton, Alberta: 1913. Photographed by Ernest Brown (PAA/B-4233).

THREE

"Canada's Century"

The *Annus Mirabilis* was 1896. That was the year the timid Tories, who had fumbled along since Sir John A. Macdonald's death in 1891, were defeated in a general election by Wilfrid Laurier's Liberals. Laurier was a master politician, a sublime practitioner of the refined Canadian art of compromise, a political balancer par excellence, with the ability to make half-measures appear positively virtuous to all sides. He was French, but acceptable to Ontario and much of the west; he was Catholic, but capable of soothing the most strident of Protestants, as he demonstrated in his capable settlement of the parochial schools question in Manitoba. He also realized perceptively that Canadians were not just transplanted Europeans. He was nationalistic but not at the expense of severing the British connection with its profitable cultural, economic, and even psychological advantages. He also had what all successful politicians and comedians must have — good timing.

Laurier came to power at a time when the world depression had eased, when there was a fall in ocean freight rates, and when international capital was anxious to find new investments. Laurier was able to take Macdonald's rusting "National Policy," re-cast it, slather it with oil, and put it to work. He achieved a broad consensus in government which gave time for prosperity to become a kind of national panacea. For a decade and more Laurier became identified with a prosperity that caused many — at home and abroad — to be convinced that Canada's century was indeed at hand.

One of the prime reasons for optimism was that the American frontier, the frontier of legend and opportunity, had now terminated. It was officially declared by the United States census bureau to be at an end. Americans, Canadians, and thousands upon thousands of European immigrants now turned to what was, if not the best, certainly the last west. Canadian immigration agents, Canadian land company representatives, Canadian con men, all switched their attention to luring would-be immigrants to settle on the Prairies. The climax of this exciting period came in 1905 with the creation of two new provinces, Alberta and Saskatchewan. Opportunities, like markets for Canadian raw materials, seemed unlimited. Old fortunes were augmented in the east and new fortunes were built in the west. For the whole period of that long, sun-drenched Edwardian afternoon Canadians

appeared to prosper as never before. Certainly the fruits of undeniable wealth could be seen in the fashionable, tree-shaded avenues of Toronto, or in the bulky baronial mansions of Sherbrooke Street in Montreal (the city which prided itself in being called "the third Scottish city of the world").

The First World War is a virtual no-man's land, separating us from the Edwardian period. Perhaps because of the horrors of that war, it is common to think of that earlier age as one of a pink-cheeked innocence. Canadians were, doubtless, better off than most in that period but rapid industrialization and urbanization had thrown up a variety of very serious social problems with which the complacent middle classes found it most difficult to grapple. Montreal and Winnipeg possessed mile upon mile of filthy slums and tenements. Social welfare and reform agencies, primitive both in concept and scope, were more inclined to treat the symptoms than to dig for the causes. But the debate about society's course and role had begun. Not many were interested — a few churchmen, some labour leaders, and an odd politician — and they struggled to come to terms with alcoholism, immigrant adjustment, urban living conditions, and, as was the particular case in Quebec, even the values inherent in industrialization itself.

There were few easy answers to these problems, and it was some while before even the right questions were asked. Overall it was an era in which the values of big business seemed to dominate and the individual's plight was lost in the shuffle.

Without question the robber barons, the free-booting captains of industry, held sway while the bulk of society was left floundering to fend off the effects of excessive individualism and its rampant vices. For Canada as well as for the United States and elsewhere, much of the late Victorian and the Edwardian period can be seen, as one historian has put it, as a time of a "search for order." In a reckless, capitalistic world people turned to social organizations to protect their interests. The rapid growth of labour unions and the less dramatic but equally compelling emergence of chambers of commerce are two strong examples of organizations and movements founded to protect both workers and business from the rigours of unfettered commercial competition. The fear could be seen too in things as trivial as the rise of college fraternities and service clubs.

There were also certain political difficulties which caused the smile below Laurier's grey mane to become a trifle forced. He had successfully avoided the inherent problems of the Boer War by permitting voluntary elements to go as Canadian representatives. It was a compromise, however, that proved too weak a commitment for the English-speaking, and too strong for the French, especially for a dissident like Henri Bourassa. The problems of commitment to a British Imperial world grew throughout the first decade of the century. Canadian foreign affairs were still handled by the British and many felt, as was exhibited by the Alaska boundary settlement of 1903, that the English were far too adept at selling out Canadian interests to placate their own ambitions.

The British Imperialists at this time were calling loudly for colonial commitment to the Imperial Navy, then being threatened by the Kaiser's ambitious dreadnaught program. Laurier was not anxious, either personally or politically, to support the Imperial naval scheme and as an alternative suggested the creation of a Canadian Navy. As with the Boer War, few were happy with the solution. The Tories quickly branded it "the tin-pot navy." Regional complaints were beginning to rankle as well. Laurier discovered in

1910 that western farmers weren't enraptured by his National Policy — everything about it cost them, they said, from freight rates to farm machinery. Farmers began to organize for collective action. Talk of American annexation was rife among some and the same talk was being heard in Washington. At this juncture Laurier resurrected the old idea of reciprocity with the United States. The timing could not have been worse. Suspicions of economic ties being converted into political ones enraged much of English Canada. All came to a head in the election of 1911 when Laurier's magic left him.

A new Tory government came to power under a sterner prime minister. Laurier, like the recently dead King Edward VII, seemed overnight to be a man from the past, although no radical realignments took place under the government of the new Prime Minister, Robert Borden. The English poet, Rupert Brooke, pinned pre-war Canada perfectly: "Canada," he wrote, "is a live country, live, but not, like the States, kicking."

The Lake St. John district, at the head of the Saguenay River in Quebec, was a noted centre for tourists, who came either by rail from Quebec City or by steamer from the St. Lawrence, via the Saguenay. The Roberval Hotel's newly constructed verandah was clearly a place to preside at the turn of the century in central Quebec.

Roberval, Quebec: c. 1900 (ANQM/N77-11-15-2).

St. George, New Brunswick: c. 1900
(PANB/MBE M-238).

The Shoreline Railroad ran along the north shore of the Bay of Fundy providing rail connection between St. Andrews (the future maritime resort terminal of Canadian Pacific), near the Maine border, and Saint John. Here, the Red Ensign snaps crisply over the roof of St. George's station, almost a third of the way along the route from St. Andrews. Typically, the photographer has got everyone to stop and look his way while he puts the required view into his sights.

Sandon, British Columbia: early 1900s (CP 1638).

Sandon, British Columbia, was a fine example of the Canadian "boom and bust" phenomenon. The site of a mineral claim in 1892, four years later it had a townsite and was the terminus of two rail lines in the Kootenays. Two thousand people lived there, and it boasted running water, electric light, churches, schools, a theatre, and a weekly newspaper. Fire, the eternal enemy, soon destroyed virtually the whole place; determination and optimism then rebuilt Sandon but the boom had left. By 1911, there were only 150 people recorded there. It is believed that this photograph was taken during the post-fire rebuilding, though the narrow street and the signs give it an earlier look.

Bamfield, British Columbia, on the west coast of Vancouver Island, in 1902 became the Pacific cable station for the "All Red" (because all British) telegraph route around the world via Fiji, New Zealand, Australia, and thence through India and the Middle East to Britain. The town was also ready to deal with massive fin whales which were being hunted voraciously in the western Pacific at the turn of the century. The operation under way, stripping off skin and blubber, is called "flensing."

Bamfield, British Columbia: c. 1901 (VPL 2582).

Victoria, British Columbia: 1900 (PABC/C-6727).

Chinese labourers had been imported for almost every type of menial work in the gold rushes and in railway construction. The end of the construction and the gold rushes brought a concentration of Chinese families into the downtown areas of the larger cities. In Victoria, a glimpse of Chinatown residents outside an importers and grocery store at Chinese New Year.

Was this the Indian compromise or at least one answer to it? Nelson, whose Indian name was Nee-shop, or Raven Crest, was the leader of this band, whose talents obviously encompassed more than cornets. His band is probably about to take part in the welcoming ceremonies for the visit of the Duke and Duchess of Cornwall and York (later King George V and Queen Mary) in September 1901.

Vancouver, British Columbia: 1901. Photographed by Edwards Brothers (CVA/JIN. P24).

St. John's, Newfoundland: 1901 (PANL/AP 5/41).

Britain's "oldest colony" continued to resist Confederation, and Newfoundland opened the twentieth century still relentlessly riding the Atlantic waves in the mouth of the St. Lawrence. No energy was spared in the illumination of the Colonial Building on Military Road, St. John's, to celebrate the accession of Edward VII.

Queen Victoria's death is marked by a memorial service at St. James's Church in Newcastle, New Brunswick. In the pulpit, beneath a shrouded portrait of Victoria, a backdrop of strong sunlight trying vainly to banish the gloom, stands the formidable Reverend William Aitken — father of the expatriate Canadian newspaper magnate and philanthropist, Max Aitken, Lord Beaverbrook. Beaverbrook, known normally as a hard-bitten, ruthless capitalist, romantically took his title from a stream by which he had played as a child in Newcastle.

Newcastle, New Brunswick: 1901. Photographed by Ole Larsen (PANB/L-2).

Quebec: c. 1905 (ANQ/N-80-3-4).

The French population in Canada at the turn of the century was far less exuberant than the English about Imperial involvement. French Canadians were very cool towards the Boer War and were becoming apprehensive about increasing non-French immigration and the growth of an industrial economy which disrupted all kinds of traditional beliefs and habits. More importantly, French-Canadian unwillingness to thrust out towards an Anglo-Saxon Imperial future was paralleled by Anglo-Saxon indifference to French linguistic and cultural priorities. And of course, there was Anglo-Saxon control of the Canadian economy, including that of Quebec itself. Wrote Abbé Lionel Groulx: "We see forming in the vast Canadian northwest a new people, strangers to our beliefs, to our race, to our political ideals, a people which grows by millions, and which we see will not respect the federal compact any more than is necessary." And Henri Bourassa, leader of *La Ligue Nationaliste Canadienne*, observed: "The whole race is at the mercy of a clever and charming opportunist, [Prime Minister] Laurier, aided by a few office-seeking and public money distributors."

Alphonse Lyonnaise and his wife stand in front of their Quebec store beside a mix of French and English which would have done Laurier proud.

A rare photograph of rural Quebec shows a curious display of brute force. It is threshing time and the thresher is driven by the family cow. Considerable concern was being displayed at this time at the move of people into the cities in Quebec, as in the rest of Canada. Much of the urban population fell into the lowly paid and abominally housed environment of small-scale manufacturing.

Pont-Neuf, Quebec: c. 1902 (ANQ/N-275-32).

La Tuque, Quebec: undated (ANQ/GH-570-118).

For many French Canadians, the old aphorism about hewers of wood and drawers of water still held good. Factory-work did not displace the dangerous, ill-paid, and seasonal labour which was the backbone of the economy of the provinces of New Brunswick and Quebec. The inexorable process of log-sorting is photographed, looking northwards up the St. Maurice River, deep in the Quebec interior at La Tuque. The river beyond is choked with logs awaiting treatment.

English Canadians, and a few privileged French, could take advantage of winter delights at Fletcher's Field, on the edge of Montreal's Mount Royal. The smog of an industrial city, even on a weekend, was fuelled by burning coal for steam heating.

Montreal, Quebec: early 1900s
(CP 1557).

Lachine rapids, Quebec: c. 1900
(UCC).

Just west of Montreal, the Lachine Canal enabled vessels to miss most of the rocky rapids of the St. Lawrence. Over the years, steamboat captains became skilled in running the Lachine rapids on the regular trips along the St. Lawrence to Brockville, Kingston, Trenton, and Toronto — the latter a twenty-seven-and-a-half-hour trip with stops. The *Rapids King*, of the Richelieu and Ontario line, would go east as far as the Saguenay River, and the *Duchess of York* was a regular side-wheeler on jaunts through the Thousand Islands.

Lachine rapids, Quebec: 1906. Photographed by Notman Studio (NPA 4205 view).

Business life in Canada was transformed by the arrival of two machines, both of which liberated and enslaved women at the same time. The effect of one of them, the telephone, is caught in this office interior photograph. The typewriter, sophisticated and reliable, had brought woman into the work force in large numbers — in an inferior working position within the office system. The telephone drew upon women to fill its exchanges and switchboards — again the supervision was male and paternalistic.

Montreal, Quebec: c. 1902 (BTC 14318).

British and Canadian journalists stopped for a fairly substantial lunch in makeshift surroundings near Indian Head, in what would soon be Saskatchewan, during Robert Borden's western political tour in September 1902. They would doubtless have visited the Dominion Experimental Station there to see how grain could thrive in the dry climate of the central Prairies. Was the world becoming interested in Canada for more than just land? A few years previously *The Times* of London had published a series of articles on Canada which had attracted broad interest, not just from the hard-pressed British workingman but from the monied classes as well.

Qu'Appelle Valley, North-West Territories: 1902 (OA/S-8719).

Opposite above: Galicians, some of whom are pictured here outside their home in Manitoba just before the First World War, were typical of many east European people who literally escaped to Canada after 1896, leaving behind an over-populated land, high taxation, and unfavourable politics. Many were destitute on arrival and clustered into Winnipeg tenements before getting work on rail-gangs or as farm labourers. They preferred to settle, once they were able, in close-knit communities where they painstakingly struggled to preserve their deeply religious habits and cultural life.

Manitoba: c. 1913 (PAC/C-6605).

(SAB/RB330).

If overseas journalists were beginning to popularize Canada, their job was more than complemented by federal and provincial government policy. Near the end of the century, Clifford Sifton, a no-nonsense Manitoba businessman, became Laurier's Minister of the Interior and set about a complete overhaul of the immigration service. The results were staggering. In 1900, 19,000 immigrants had come to Canada from the United States — in 1913, 139,000 came; from Britain in 1900, 1,200 immigrants had come — in 1913, 150,000. Eastern Europe furnished Sifton's ideal immigrant, "a stalwart peasant in a sheepskin coat, born on the soil... with a stout wife and a half-dozen children"; in 1900, 6,000 stalwart peasants — in 1913, 21,000. Others came from the Orient and India. Canada's population increased dramatically in the first quarter of the century as did the amount of land under agricultural cultivation. A ten-furrow Reeves plough is pictured breaking land near Regina, a railroad embankment and a telegraph line in the background. Mechanizing prairie agriculture was crucial if the agricultural yield was to increase. Americans were particularly efficient at putting acreage under the plough and achieving spectacular yields in double-quick time. The Mormons who moved into southern Alberta from Utah were especially knowledgeable about farming under arid conditions.

Langham, Saskatchewan: 1903
(GA/NA-663-1).

The nude march became a protest call for a radical Doukhobor group, the *Svobodniki* or Sons of Freedom. Clifford Sifton had enabled the persecuted Russian Doukhobors to reach Canada in 1898, with an agreement settling the sect (about seventy-four hundred members ultimately) on 400,000 acres near Yorkton. When their leader, Peter Veregin, arrived in Canada from Siberia in 1902, nearly eighteen hundred men, women, and children trekked east to meet him in Winnipeg. The following year, the Sons of Freedom began the first of a series of nude protests against Veregin, who saw the need to settle a peaceful community, and the Canadian government, which seemed to them to be showing signs of Tsarist hostility after Sifton left office in 1905. The next seven years saw confiscation of Doukhobor lands in Saskatchewan under various pretexts, and Veregin moved his sect to the British Columbia Kootenays.

The end of territorial status for Saskatchewan and Alberta in 1905 had been on the books for some time. What it brought up with a vengeance was the question of education and minority rights, just as it had done in Manitoba in 1890. Laurier played it cool on these issues, but it became plain that Ottawa's attempts to give the new provinces equity in such questions while simultaneously placating Roman Catholic hostility in the east, were raising concern in Quebec about the status of French Canadians in a nation of such vigorous immigration. The most alarming note of future disruption for Laurier came from a Quebec nationalist, Armand Lavergne, in September 1905: "In constituting the French Canadian, who has lived in the country since its discovery, the equal in rights and privileges to the Doukhobor or the Galacian [sic] who has just disembarked, we have opened a gulf between eastern and western Canadians which nothing will fill."

The Governor General and Lady Grey journeyed west for the provincial inauguration ceremonies, and the Regina *Leader* clearly was too overcome to notice that it was still running a North-West Territories head on September 6! As Saskatchewan and Alberta joined the new century, the Canadian Pacific Railway was plainly to have competition. The Canadian Northern line coming east from Quebec already had end of steel at North Battleford en route for Edmonton. The prospective line of the Grand Trunk Pacific would head west for Edmonton and Prince Rupert on the Pacific coast.

Regina, Saskatchewan: 1905 (SAB/RB-B-8338/9).

Cannington Manor, Saskatchewan c. 1905. Photographed by A. B. Thom (US/Mss C 555/2/14.7 no. 56).

One of the odder communities to put down roots as Canadian Pacific steel edged out across the Prairies was Cannington Manor. On the lands about Moose Mountain, in the North-West Territories, Captain Edward Mitchell Pierce, an English estate bankrupt, settled his large family amongst all the trappings — including servants — of English country life. A visit to the Marquess of Lorne and a word with Sir John A. in Ottawa en route west in 1882 had opened up land previously closed to homesteaders. Captain Pierce built a manor house and collected a village of church, smithy, carpenter shop, even a hotel (called the Mitre), and a dormitory to which he encouraged the attendance of the sons of well-to-do English gentry for "agricultural instruction" — at £100 "all found." The three Beckton brothers, Ernest, Billy, and Bertie, who arrived in 1889, not only built a massive stone house at Cannington but imported bull terriers and foxhounds, held annual Hunt Balls in full formal dress, built a racing stable and course, and played all the appropriate games of the English public school. These products of the romantic idea of Empire had lost all their money by the end of the century; their credibility had vanished long before.

Steele & Co., a Winnipeg photography studio, took this view of the bar of the Windsor Hotel, Saskatoon, in 1903. Liquor, like brothels, was as much a part of opening up the west as land was, and prohibitionists were most zealous in their assaults upon its open sale and use in the North-West. The Women's Christian Temperance Union would happily have closed down the rash of bars, poolrooms, and brothels which made substantial incomes for their proprietors and contributed in the Prairies, as elsewhere in the world, to social ills. Manitoba, in fact, was at first dry, although licencing of hotels soon became necessary. Ontario prohibitionists waged a fierce war in the North-West Territories to no avail, the Mounted Police could not hope to enforce prohibition, and licencing began in 1891.

Saskatoon, Saskatchewan: 1903. Photographed by Steele & Co. (SAB/RB 973).

Banff, Alberta: c. 1905 (UCC).

The Banff Springs Hotel was quite substantial by 1905, still basically of frame construction, however, not yet the massive stone structure it would become. Still, the hotel had all the luxuries with which the Canadian Pacific Railway could equip it, and it attracted visitors from around the world, many of whom might take the four-horse stage up from the CPR station in the town of Banff.

An indoor curling rink, possibly at Carievale, Saskatchewan, suffered from the effects of a three-day blizzard circa 1905 (SAB/RA-5610).

A walking party crosses the suspension bridge thrown across Capilano Canyon, North Vancouver; genteel Sunday afternoon excitement. 1903 (CVA/BRP-59).

British Columbia's political difficulties were rampant by 1905, though outwardly Victoria seemed to retain its sleepy look. Strikes were becoming more frequent as industrial workers (in mining, fish processing, and lumbering) unionised with powerful backing from the American Federation of Labour. In 1903 a Royal Commission had investigated industrial disputes specifically in B.C. Quite obviously too, British Columbia had become disenchanted with the economic "benefits" of Confederation — it seemed as if eastern interests had taken what they wanted and left only the likes of the Dunsmuirs to extract the rest.

Victoria, British Columbia: 1903 (VPL 3319).

An Edwardian Portrait—People

L'Ange Gardiens, Quebec: haying in August 1905 (OA/S-8871).

Quebec City, Quebec: garment factory interior, c. 1905 (ANQ/N79-12-43).

British Columbia: halibut fisherman, c. 1914 (PABC/E-1690).

Newmarket, Ontario: W. R. Byers's telephone construction crew, April 1906 (BTC 4610).

Shawinigan, Quebec: master barber Wilfrid Cormier, 1904 (ANQ/N-673-124).

Clarkson, Ontario: back-porch entertainment, 1906 (OA/S-9108).

98

Church Point, Nova Scotia: St. Anne's College teachers take meteorological observations from the roof, 1907 (OA/S-9165).

St. John's, Newfoundland: unloading seal pelts from Labrador, date not known (UCC).

Above left: Sheho, Saskatchewan: Bukovinian mother and child in native costume, c. 1907 (PAM Sisler 68).

Above right: Glace Bay, Nova Scotia: operator of Marconi Wireless and Telegraph Company station at Table Head sending Canada's first commercial relay to Ireland, October 17, 1907 (PANS Acc. 8609).

Manitoba: Icelandic settlers Ketill Valgardsson and his wife, c. 1908 (PAM New Iceland 135).

Toronto, Ontario: men and women at mill looms, c. 1907. Photographed by W. James (CTA/James 137).

Burgeo, Newfoundland: drying cod fish at a south shore outport community, 1908. Photographed by Notman Studio (NPA 4613 view).

New Brunswick, possibly Caraquet: cross erection in an Acadian community, 1908 (PANB/Men 231).

Calgary, Alberta: the Calgary Cricket Club XI, 1908 (GA/NA-468-16).

Toronto, Ontario: on the banks of the Don River, c. 1908. Photographed by W. James (CTA/James 7339).

Interior of a colonist car on the CPR with bunks partly made up, c. 1908 (SAB/RB-3275(2)).

Yukon Territory: the Royal Mail sleigh connecting with the White Pass and Yukon Railway, 1908 (ACC/P 7517-464).

Alberta: Lord Strathcona talks with Father Albert Lacombe; the CPR president and the western missionary; the man who brought the most profound changes to the west with the man who struggled in vain to cushion the impact of rail upon the Indian; 1909. Photographed by Byron-May Company (NPA 289, 652-BII).

Port Dover, Ontario: summer bathing in Lake Erie, 1911 (OA/S-9745).

Whitewood, Saskatchewan: John and Harry Howard clearing field stones. John Howard was an amateur photographer who made his own cameras; c. 1910 (SAB/RA 6190).

Ottawa, Ontario: toboggan slide below the Chateau Laurier Hotel site alongside the Rideau Canal locks, c. 1910 (COA 0057).

Quebec City, Quebec: German immigrant family at rail station, c. 1911 (PAC/PA-10254).

Camp Sewell, Manitoba: Major Simpson of the 27th Light Horse, with his horse "Tootsie", 1913 (PAM Camp Sewell 44).

Toronto, Ontario: boating at Centre Island, 1910. Photographed by James & Son (EA).

Winnipeg, Manitoba: the start of the first T. Eaton Company Santa Claus Parade for which there is a photographic record. Since it began far out on Portage Avenue and never boasted more than the two buglers, two floats, and eight horses seen in this photograph, it looked rather like Napoleon's retreat from Moscow. November 14, 1914 (EA).

Winnipeg, Manitoba: Santa and his helpers in Eaton's toyland, 1913 (EA).

An Edwardian Portrait—Places

Quebec City, Quebec: the Chateau Frontenac, Dufferin Terrace, Heights of Abraham and waterfront from the St. Lawrence River, c. 1913 (PAC/PA-21360).

Quebec City, Quebec: the Dufferin Terrace below the Canadian Pacific hotel, Chateau Frontenac at the time of the Tercentenary celebrations, July 19, 1908 (OA/S-9247).

Quebec City, Quebec: below the Dufferin Terrace outside the Customs House, c. 1911 (PAC/PA-21358).

Chicoutimi, Quebec: on the Saguenay River, c. 1910. Photographed by Notman Studio (ANQ/N-78-8-124).

Charlottetown, Prince Edward Island: early aviation, c. 1912 (PAPEI Turner 25).

Calgary, Alberta: 8th Avenue from 1st Street West, 1912 (GA/NA-644-11).

Edmonton, Alberta: oil promotion at Doll's Jewellery Store, 1914 (PAA/P-1088).

Regina, Saskatchewan: streetcar by the Board of Trade building, c. 1908 (SAB/RB-9443).

Regina, Saskatchewan: damage caused by the cyclone. This is Victoria Park in the city centre, 1912 (SPL).

Winnipeg, Manitoba: after the fire at the Kelly Block, Bannatyne Avenue, January 1911. Photographed by John Foote (PAM/N-1828).

Montreal, Quebec: constructing the Canadian Pacific Railway's Windsor Station, 1911 (CP 23841).

Sherbrooke, Quebec: the "Motor Mart" on Minto Street; the first Imperial Oil dealership in the Eastern Townships, 1913 (IOA).

Maugerville, New Brunswick: river landing, early 1900s (PANB/P 39-4).

Winnipeg, Manitoba: Assiniboine Park access bridge, 1912 (PAM/N-2258 Foote collection).

St. Boniface, Manitoba: J. B. LeClerc Tobacco Store interior, 1912 (PAM St. Bon. Buildings-Business).

Vancouver, British Columbia: pioneer shack with a difference; bedroom is in left stump over living room and kitchen in right stump, date unknown (CVA/BU. P.6).

Boundaries between nations continued to matter, especially the arbitrary line fixed between Canada and the United States of America. Personal friendships between citizens of the two countries were never better or more prolific, but on economic matters like reciprocity, affairs were cool. Canada distrusted British and American behind-the-scenes diplomacy as was exhibited in the Alaska boundary settlement. But, American newspapers continued to be delivered in Canada...in this case by Cyril and Claude Parkinson of Kamsack, Saskatchewan.

In British Columbia, ugly racist matters were surfacing — first against the Chinese and then against the Hindus. Since 1900, when East Indians and Japanese had begun to join the Chinese population of the province, the cry for exclusion had been ringing loudly. Some of the pressure had forced Ottawa to amend the Immigration Act in 1910 to exclude "undesirables." R. B. Bennett had warned a near-paranoid British Columbia audience in 1907 that "British Columbia must remain a white man's country." An Asiatic Exclusion League was formed in August 1907 and riots broke out against the Japanese — some of whom were, it seemed, being brought over as cheap labour by the Canadian Pacific Railway in collusion with the government of Japan. These Chinese cannery workers in a photograph entitled "Just a Whiff" are smoking opium.

Kamsack, Saskatchewan: c. 1913 (SAB/RA-4106).

British Columbia: c. 1913 (PABC/E-5065).

What kind of society did Canadians want to create? Was Sifton's "come one, come all" policy the only way? Obviously, a number of Canadians thought not. One of the clearest expressions of the growing hatred of "other peoples" took place in Vancouver in the summer of 1914, just before Canadians began to flock obediently and naturally to Britain's side in the war against Germany. A Japanese vessel, the s.s. *Komagata Maru*, reached Vancouver with 376 East Indians on board. The voyage had been sponsored by a wealthy Punjabi merchant who hoped to test Canadian regulations excluding these British subjects from Canada. The vessel lay two months in the harbour, forbidden by Ottawa to land its passengers and the butt of local derision. Discussions were held between the East Indians and officials, seen here boarding the *Komagata Maru*. H.M.C.S. *Rainbow* (one of two cruisers in the "tin pot navy") ultimately escorted the *Komagata Maru* to sea in July 1914 — her one and only bout of active service! Both vessels are seen here, the *Rainbow* on the right looking slightly poorer for wear than the Japanese vessel.

Vancouver, British Columbia: 1914 (PABC/D-5577).

Vancouver, British Columbia: 1914 (VPL 6229).

119

The Battle of Beaver Dams in the War of 1812, when the Caughnawaga Indians routed an American force and Laura Secord was made a heroine, was celebrated by some forty-five United Empire Loyalists on the edge of the first Welland Canal. Loyalism to the British Empire and the Crown still counted for a great deal in pre-war Canada.

Thorold, Ontario: 1914 (PAC/PA-51572).

Vancouver, British Columbia: 1910 (CVA Mil. p. 320).

General Baden-Powell, founder of the Boy Scouts, visited the 1st Vancouver Troop in Hastings Park in August 1910. The Vancouver scouts had the distinction of being not only the first troop in Canada (having been established barely a year) but the first in the British Empire beyond the British Isles. There is a vitality and spontaneity in this picture — a dynamic which improved cameras were increasingly able to capture.

120

Men of the 28th Field Artillery Battery drill near Newcastle, New Brunswick, just prior to the outbreak of the First World War and a Canadian call to arms: a call which was greeted with bounding enthusiasm "to put forth every effort," promised Prime Minister Robert Borden "and to make every sacrifice necessary to ensure the integrity and maintain the honour of our Empire." Borden, however, confidently believed that the effort and sacrifice would be quite voluntary and that Canada's youth all stood ready to sail for Europe. He was wrong.

Newcastle, New Brunswick: c. 1913. Photographed by Ole Larsen (PANB/L-498).

Prince Edward Island: c. 1913 (PAPEI).

The end of a very long Imperial afternoon.

Gaspereau, King's County, Nova Scotia:
1907 (OA/S-9202).

News of the declaration of war in Europe reaches downtown Winnipeg. Newsboys skip between the streetcars on Portage Street and men cluster to read the headlines.

Winnipeg, Manitoba: 1914 (PAM Burns 684).

FOUR

Tribal Obligations

For most of the tense, hot summer of 1914 Canadians thought little about war. They had more pressing concerns than political events half a world away, such as pumping life into a flagging economy, reconciling the effects of rapid industrialization and ugly urban sprawl with the great polyglot influx of immigrants, and simply attending to the thousand and one details of everyday life.

When the entangling alliances of Imperial Europe snared Britain into war, her Canadian colony automatically and dutifully found itself in the same predicament. Most didn't consider it a predicament at all. In common with their British cousins, few had any idea of what modern warfare represented beyond a kind of *Boy's Own* adventure tale of British pluck. So war was greeted enthusiastically — even in French and Catholic Quebec.

Of course, Canada was filled with British immigrants who flocked to join up, many prompted by their poverty. The early calls for men were quickly satisfied and the First Canadian Division set sail in October — intending to be back if not by Christmas, definitely quite soon thereafter. Without question these men, the nurses who accompanied them, and those who followed, whether they fought on the western front, at sea, in the air, or as far afield as Siberia, distinguished themselves and their hitherto-unknown country. The war effectively catapulted Canada into the consciousness of the world, and, in fact, gave the country a strong sense of its own worth.

If the military effort was admirable, equally impressive for a small nation of seven and a half million was the transformation on the home front. Canadian industry expanded and diversified, and was streamlined into an effective machine that finally produced all the implements of modern warfare. In the same fashion Canada at last really did become Europe's granary. In the factories, offices, and shops of the land women replaced men in much of the clerical and industrial work — particularly in the manufacture of munitions. And on the farms there was a growing concern about manpower shortages. Agricultural work was crucial, for more than armies travelled on their stomachs. Were not men working in the fields of Saskatchewan as essential to victory as troops drilling on England's drenched Salisbury Plain? As the war continued the answers became mixed.

War is blood sport and as the blood-letting became more apparent there came a need for something more than the voluntary enlistment that had built Canada's, and, indeed, England's forces since the war's outbreak. The adoption of conscription in 1917, arguably unnecessary, probably did more to cleave the country on ethnic lines than has any other event between Confederation and the present. War fever reached a frenzied pitch as an orgy of fervid patriotism engulfed the country. Quebecers were viewed as not doing their share. Women won the vote in 1917, only because, some cynical observers noted, they would endorse conscription to aid their men. Patriotic excess reached its peak that year as profiteers real and alleged were roasted, and waves of committees were charged to excoriate any German links and terms, whether the playing of Wagner's music or the old names of streets and towns. In such an atmosphere, temperance was not only morally correct, it was an absolute patriotic duty.

These tensions strained Canada's society, and stretched the tenuous Imperial tie to near breaking point. At the war's end, Canada was a changed place.

The end of Canadian innocence brought with it a certain self-respect and self-confidence. The casualties, sixty-one thousand dead and thousands more wounded, were bad enough, but the country remained divided: industrial east isolated from agrarian west, Quebec isolated from the rest because of conscription and the political alienation that had accompanied it. Moreover, the returning troops looked for the rewards of a world they had made safe for democracy. The bold talk of Woodrow Wilson's Fourteen points, of a League of Nations, of continuous prosperity persuaded very few. They soon saw that those who had held sway before they had left for the trenches were themselves even more entrenched in their comfortable postures of authority.

For some, the Bolshevik Revolution in Russia in 1917 provided the real opportunity for a changed world. Radical labour movements found a good deal of appeal, especially in the west. The Winnipeg General Strike of 1919 — an orderly, intelligent grievance — was considered by Dominion authorities to be the wildest Red Scare of them all. In fact, viciously suppressed as it was, the strike showed the labour movement the futility of struggling against the united politics of privilege in Canada. New political expressions by the restive workers themselves would be required to dislodge the old order. In short, the Canada of 1919 was a very different place from that of 1914; Canada's century had slipped away, and the land of opportunity seemed tarnished. Even if pre-war Canada had not been cast in a golden hue, it would be remembered as such, a time of fond innocence in sharp contrast to the corrupt, scheming Europe that had led the world to war. Real innocence lost could never be regained — although, in charting a course for Canada in years to come the political shamans would always make an effort.

The creator of Sherlock Holmes, Sir Arthur Conan Doyle, raised the flag on a visit to the Yellowhead Pass — the northern rail route through the Rockies. The Grand Trunk Pacific had still not built the final section of its route to Prince Rupert by June 1913 when it turned to the Canadian government's door for a $15 million loan, claiming a promise from the previous Laurier administration. The government made the loan, and, in 1914, guaranteed a further $16 million on Grand Trunk bonds — this despite a commitment to its own railroad, the National Transcontinental from Winnipeg to Moncton. As the war drew close, a number of financiers and business leaders were saying that the government might just as well take over the whole Grand Trunk–National Transcontinental system and add in the peppy Canadian Northern for good measure. In the spring of 1914, following a painstaking investigation of Canadian Northern's Toronto offices, the Borden government assumed a mortgage on the company, $33 million of company stock, and guaranteed $45 million of Canadian Northern bonds! What price national communication?

Yellowhead Pass, British Columbia–Alberta border: c. 1914 (PAA/A-2925).

"You said you would go when you were needed. You are needed NOW!" shout the posters at this Milton, Ontario, recruiting office, while in Winnipeg, it was hoped that a re-creation of trench warfare at Main Street and Water Avenue would draw recruits. Conscription was delayed for at least half the war because it was not thought necessary — volunteers would be quite sufficient for the Canadian Expeditionary Force. Of course, no one thought the war would last long anyway. More acutely, the Dominion government was well aware of Quebec's antipathy to being involved on any compulsory basis in an Imperial scrap between Britain and Germany. All through 1916 the feeling between English and French Canadians grew more tense, despite the *bonne entente* movements which tried to bridge an unbridgeable gulf. By 1917, there were at least twenty thousand casualties per month amongst Canadians in Europe, but only three thousand willing to back them up by enlisting. A month-long campaign in Quebec in May that year produced only ninety-two volunteers. Conscription was thought to be inevitable to keep faith with the men at the front, and to show that Canada had a right to equal status in the Empire. Anti-conscription riots broke out in Montreal on May 24, but the new Military Service Act went into force, admittedly with some misgivings on Borden's part as he saw Canada split into two unequal portions. Meanwhile, Victory bonds were being pushed, in Regina by Boy Scouts, and in Toronto by displays of brute military force: on a tree-lined residential street, a tank crushes a car.

Milton, Ontario: c. 1916 (OA/S-15042).

Winnipeg, Manitoba: 1916 (PAM/N-2972). Toronto, Ontario: c. 1916 (CTA/James 733B).

Regina, Saskatchewan: 1918 (SAB/RB-8132 (48)).

News of the German U-boat sinking of the American passenger liner *Lusitania* reached Victoria in the afternoon of May 8, 1915. In the evening a crowd attacked the German-owned Kaiserhof Hotel and wrecked as much of the interior as they could. The flash photograph taken from the Bell Telephone building shows the police line around the hotel and men and women tentatively wondering where to go next — possibly Leiser's store down on Yates Street since they had already demolished the German Club on Government Street. Businesses with German names had reason to feel threatened. Many changed their names at this time, just as in Ontario, the town of Berlin became Kitchener, and back in Britain, the Royal family's name was changed from Saxe-Coburg Gotha to Windsor.

Victoria, British Columbia: 1915 (PABC/A-2709).

Victoria, British Columbia: 1915. Photographed by Trio (PABC/C-7552).

Toronto, Ontario: 1917 (EA).

Frances Loring, sculptress, on the left, her assistant, Miss Scobie, on the right, made an enormous "Miss Canada" in 1917. Eaton's patriotically displayed the plaster figure over the north Yonge Street door of its Toronto store.

Keeping the Home
Fires Burning

Manitoba: outdoor bake oven, 1916 (PAM Sisler 101).

Stillwater, British Columbia: 1916 (CVA/LOG. p.42).

The war brought a decided change in Canadian attitudes towards women, not only because of their support of patriotic home service organisations and volunteer reserves, but because of their crucial role in industrial operations and on farms. Thousands of women were recruited into jobs that had traditionally been closed to them and more than thirty thousand were employed in munitions factories. This cheerful group is from Toronto's Nobel cordite plant.

Toronto, Ontario: 1915 (CTA/James 860).

Walden, Saskatchewan: c. 1916 (US/A-1422).

Saskatoon's College of Agriculture enterprisingly entered into an agreement with the Canadian Pacific Railway in 1915. A train of eighteen cars, including restaurant, sleeping facilities, lecture rooms, child-care, machinery, and livestock exhibits, travelled to small rural communities across the province. Families journeyed miles across the Prairie to the station stops. Thousands of people visited the Better Farming Train over its six weeks on the move every June and July between 1915 and 1918. These pictures show the livestock car and the magic lantern car.

Saskatchewan: c. 1917 (US/A-1499).

Saskatoon, Saskatchewan: 1915 (SPL).

One thing for sure, not all Canadians were deprived during the First World War, as the Christmas display at the Central Meat Market in Saskatoon shows. And the "drink more milk" exhibit at the Collège de St. Casimir does not smack of hardships.

Pont-Neuf, Quebec: 1914 (ANQ/N-78-11-7).

135

White Mud River, Manitoba: cutting ice blocks for refrigeration, 1916. Photographed by Cyril Jessop (PAM Jessop 179).

Manitoba: c. 1915 (PAM/N-231).

Christmas at a prisoner-of-war camp, somewhere in Canada, 1916 (PAC/C-14104).

Children outside *L'Ecole Brébeuf* in Ottawa in 1917 protested the implications of a British Privy Council ruling that Ontario's "Regulation 17", passed in 1912, was quite valid. For nearly a decade, Franco-Ontarians (and Franco-Manitobans) had been insisting on the right to have public funding of a bilingual education system. Regulation 17 denied separate school boards any money unless they employed teachers fully capable of teaching in English. It represented fundamental divisions which were inflamed by right-wing groups on both sides. The Privy Council decisions solved absolutely nothing, and passions ran very deep as attentions were turned from language to military service issues. One of the most moderate and reasonable voices emerged from the Quebec legislature in January 1915 when members acknowledged unanimously that "one of the fundamental principles of British liberty in all of the Empire is respect for the rights and privileges of minorities." The taller sign aboard the Ottawa sleigh reads: "Is not British fair play for us too?"

Ottawa, Ontario: 1917 (CRCCF/Ph2-143).

Moncton, New Brunswick (UCC).

The Great War raised patriotism to new heights in Canada. Prohibitionists (mostly white Anglo-Saxon Protestants), who had been active provincially for years, seized upon war needs to elevate "Dry" into a matter of national virtue. By April 1917, with prohibition declared in all the provinces, and noisy evangelical rallies even in Quebec, prohibition was pure patriotism. In December of that year a total prohibition was imposed on the making, importing, or carrying of any drink with more than two and a half per cent alcohol content. A year later with the war ended, troops returning home, and moderates in charge, most agreed that the controlled public sale of liquor seemed much more sensible.

A rare view (unfortunately damaged) of Chinese labourers en route to France, taken at William Head quarantine station near Victoria, British Columbia, on March 28, 1918. This was the last batch of contract labour hired by British authorities to perform menial chores for the armies entrenched in Europe. Seventy-five hundred men stood for this photograph. (PABC/C-9581).

A virulent influenza epidemic swept Canada at the end of the war, claiming thousands upon thousands of victims. Returning soldiers, tight-packed into troopships or wedged into railway cars, are thought to have efficiently distributed the disease nationwide. Casualties were highest in war-weary Europe, amongst a population already laid low by poor nutrition and scarce fuel. Throughout the world, it is estimated that the influenza epidemic claimed twenty-five million victims.

High River, Alberta: 1918 (GA/NA-3452-2).

Winnipeggers looked with amusement and not a little envy at the obvious oblivion of free-wheeling "Bicycle Bill," who was in the middle of his cross-Canada tour on May 4, 1918. Winnipeg, Manitoba: 1918 (PAM/N-2531).

Canadians had a perfectly simple reason for remembering northeastern France and Belgium: just under one-tenth of all the Canadian men and women who served in army, navy, or British air force had been killed there. There had been a hundred and seventy-three thousand casualties including thousands who were left badly handicapped. This sign is at Windsor Station in Montreal.

Montreal, Quebec: 1918 (UCC).

As the First World War drew to its conclusion, organized labour — especially in the Canadian west — grew more militant. A vast increase in union membership had occurred during the war years and had been accompanied by a phenomenal rise in the cost of living — eighteen per cent in 1917 alone. A number of industries struck throughout the country; coal in Alberta and Nova Scotia, garments manufacturing in Quebec, and public utilities everywhere. As it turned out, however, the sharpest confrontation would be at Winnipeg in 1919.

The affair began innocently enough with a strike in the Metals and Building Trades industries over the issues of union recognition and the right to collective bargaining. The local Trades and Labour Council helped to convert this into a sympathetic general strike focusing on the issue of collective bargaining.

Some thirty-five thousand workers responded. In the background municipal, provincial, and especially the federal governments feared it was all part of an international Communist-inspired conspiracy. It clearly had to be stopped. Local police were sympathetic to the strikers, so were replaced by the military and by special squads of Mounted Police. A Citizens' Committee and a Strike Committee had great trouble finding any common ground in the effectively besieged city and openly hurled abuse at each other, some talking of revolutions and force, others of the Riot Act and force.

Events turned very sour — and violent — on June 21, "Bloody Saturday." A parade to protest arrests of strikers was scheduled. It turned ugly when Mounted Police fired into the crowd, killing two strikers. This violence broke the back of the strike. Seditious conspiracy charges were subsequently laid against the strike leaders and a bitter taste left for the whole labour movement. Perhaps the most significant aspect of the general strike was that it did not recur. Labour realized that to be effective, it would have to organize as a political party.

Winnipeg, Manitoba: Women volunteer to operate gas pumps during the strike. By labour's definition, they have to be scabs, 1919. Photographed by Lewis B. Foote (PAM/N-2736).

Above left: Winnipeg, Manitoba: Main Street north from Portage, undated (PAM/N-908).

Winnipeg, Manitoba: Crowds at Victoria Park during the strike, 1919. Photographed by Lewis B. Foote (PAM/N-2748).

143

Bathurst, New Brunswick: 1919
(PANB/MIS 484-19).

The Bathurst Lumber Company's 1919 workers' picnic might well be seen as a portent of things to come, as well as a reflection of company paternalism. Getting a job, finding a house, feeding a family, playing a game — all could be provided for by a corporate giant, often foreign owned, whose face would never need to be on the boards in a blueberry pie. The Bathurst Lumber Company, of course, later became part of the modern pulp, paper, and power corporation, Consolidated-Bathurst, Inc.

Rich Man, Poor Man...

The prosperity that marked the 1920s largely resembled the pre-war economic boom. Once again the primacy of wheat in the economy and the role of the immigrant in industry and agriculture were significant. More than a million and a quarter immigrants came to Canada in that decade, and about forty per cent of the world's wheat was produced in the west. Yet Canada's prosperity was founded on more than the old prairie formula. Increasingly, mining, pulp and paper, electricity, and other resource industries were playing an instrumental role in the economy. The idea of the Canadian north as the repository of the future riches of the country fired imaginations as had the vision of the west half a century before. And, with the opening of the north, the flow of prosperity shifted from the traditional east-west axis to a north-south one as American influences and American capital fuelled the north's exploration, particularly in Ontario.

In social terms the return to a peacetime economy produced many novel problems including the absorption of veterans, the transformation from war-time to peace-time production, and the replacement of war-time markets. Paramount, of course, were the political accommodations that would have to accompany these shifts, especially the divisions effected by the conscription issue and problems regarding the distribution of responsibilities between federal and provincial governments. Government during the war had been huge and shambling, with a finger rightly in every economic pie; now the government in Ottawa drew its fingers out.

The federal and provincial governments co-operated in establishing employment centres to resettle veterans, loans were made to returned soldiers, training and education schemes instituted, as well as some land grants distributed. It was not as sophisticated a plan as that instituted after the Second World War, but it was a start and it assured that the government had some understanding of post-war problems. However, for most who suffered from the recession that occurred in Canada immediately after the war, the scheme was the merest window-dressing, and the early 1920s scarcely saw the roaring prosperity so fondly stereotyped by popular chroniclers. In fact, much of the popular impression of Canada in the 1920s is based on borrowed American models.

Even so, the mass media did make its first electronic appearance in Canada in the 1920s, and had as complete an effect on the leisure habits of the population as the automobile did on sexual mores, or the production-line on the manufacture of consumer goods. Not everyone could afford the new gadgetry of the post-war world, but it was increasingly accessible to many, thanks to techniques perfected in war-time. As a result automobiles and household appliances became not the cherished playthings of a pampered few, but everyone's everyday domestic furniture.

Politically, there was an abrogation of power by the federal government — viewed by many as a logical retreat after the active years of nation-building and the enormous government commitment to directing the war. This exit left a power vacuum which was filled by provincial and local governments. The citizens of the 1920s demanded more and more of their governments in the way of social legislation and regulation: hospitalization, workmen's compensation, highways, and housing are a few examples. Provincial governments jumped into the gap and assumed these new responsibilities, even though they had to implement their policies from a very slender tax-base, a base dependent largely upon the taxation of luxury items, like the automobile itself, or gasoline and liquor.

A second feature of political life in the 1920s was the widespread discontent which precipitated what has been called the agrarian "revolt." This was partly an extension of farmers' grievances which had been generated throughout the war, and partly the last wail of protest from a country that in 1921 officially became more urban than rural. Although at the national level the farmers' protest was unsuccessful, dissipating itself in the vague pronouncements of the Progressive party, farmer governments were elected in the west and even Ontario, and new political bases were created which would bring different political questions as well as answers in the 1930s.

In the meantime, Canada had achieved a cocky autonomy during the First World War, and, in the decade following, steps were taken to give legal force to what many considered established fact. If it did not deny the British link certainly Canada downplayed it. Canada had signed the Treaty of Versailles independently, although still under the British delegation. Three years later when Britain looked to the Dominion for unflinching support over its intrusion in Turkey, Canada flinched. A year after that the Canadian equivalent of a Declaration of Independence was suspected by a considerably outraged British Minister in Washington, when Canada independently endorsed a fishing treaty with the United States.

Any idea of a common Imperial foreign policy was now dead, and Lord Balfour's declaration that the Dominions were "autonomous entities under the British Empire" was viewed by many as the just culmination of the long constitutional path first laid out by Lord Durham's report almost a century before. By the time of the Statute of Westminster in 1931, however, whether a nation was in charge of its own destiny or not seemed rather an academic point: the global depression had descended and Canada's economy was proving to be more vulnerable than most. Canada's society and politics, as always, would soon go the way of its economy.

Quebec City, Quebec: 1921 (PAM/Transpo-Air 33).

Though the first plane actually to fly in Canada had taken off in Baddeck, Nova Scotia, before the First World War, and though almost twenty-four thousand Canadians had served with the Royal Flying Corps during the war, by 1920 most Canadians still had not seen a plane in flight. During the next two decades, Canada's northern reaches, particularly in Quebec, Ontario, Manitoba, and Alberta, were literally opened up by the new flyers, many of them ex-servicemen working for small charter companies carrying supplies into the bush or for provincial government aerial fire protection services. They flew tiny planes similar to this seaplane high over Quebec City.

These bush pilots brought off many daring trips and one or two of them were among the first pilots of Canadian Pacific and Trans Canada airlines when they began commercial operations in the 1930s. The very first license issued, to Roland John Groome in 1920, is reproduced here. C. M. "Punch" Dickens, one of the most intrepid of the early flyers, observed: "I'm proud of the title 'bush pilot.' It originated in Canada, it relates to men of dedicated interest in flying to the remote regions, and I hope it will never disappear."

Regina, Saskatchewan: 1920 (SAB/RB-3838).

147

White Jazz and the "Roaring Twenties" would not escape Canadian clutches despite the war tax levied even on "artists of syncopation" — one of the hangovers of an inflationary economy. Winnipeggers in 1923 could scarcely resist seeing if the great American escape artist, Harry Houdini (in top left of photograph), could release himself from a straightjacket thirty feet above Carlton Street. He could and did.

Winnipeg, Manitoba: 1919 (PAM 229).

Winnipeg, Manitoba: 1923. Photographed by Lewis B. Foote (PAM/N-3054).

Quebec; a northern wilderness guide, c. 1920 (UCC).

Toronto, Ontario: Sir Henry Pellatt, builder and owner of the monstrous Toronto folly, Casa Loma, which eventually bankrupted him, resplendent in the uniform of the Queen's Own Rifles at the Canadian National Exhibition stadium, c. 1920 (CTA/James 4012).

Toronto, Ontario: mostly American news headlines on a *Globe* poster c. 1920 (CTA/James 296).

Vancouver, British Columbia: 1926 (CVA/96-2).

With war taxes and rationing out of the way by the mid-1920s, more normal matters like drinking good fresh milk and eating well received publicity.

Vancouver, British Columbia: a cafeteria worker at British Columbia Telephones, 1928 (CVA/17-492).

The "Return to Normalcy"

Vancouver, British Columbia: telephone engineer splicing cables in the basement of Kerrisdale suburban exchange, 1926. Photographed by Len Frank (CVA/17-225).

Winnipeg, Manitoba: Jewish ladies' "stag" party, 1920. Photographed by Lewis B. Foote (PAM/N-2448).

Toronto, Ontario: second Union Station and railyard in winter, 1926 (PAC/PA-87691).

Saskatoon, Saskatchewan: the University of Saskatoon exploring alternative energy supplies for a Canadian-built car, the McLaughlin model D45 from Oshawa, Ontario, 1919 (US/A-2426).

Charlottetown, Prince Edward Island: salesman and clients in the furnishing department of Holman's Department Store, c. 1920. Photographed by Read (PAPEI 2930).

Kenora, Ontario: the splendid lunch counter of Canadian Pacific's station, c. 1921 (CP/A-13082).

Alberta; "registering" at Camp Parker recreational camp, 1921 (PAA/P-6934).

Ste-Anne-de-Beaupré, Quebec: Main street, looking past the "Cyclorama." The hotels and accommodations testify to the purpose of this international mecca, the shrine called the "Lourdes of North America," c. 1925 (UCC).

En route: Canadian Pacific's publicity photograph shows how rail travel *should* be done (CP/A-1981).

Winnipeg, Manitoba: rides await on a ski-plane in River Park — if you dare, 1924. Photographed by Lewis B. Foote (PAM/N-2641).

Toronto, Ontario: the city's finest learn "how to" at Grover, Toronto's first dial exchange, 1924 (BTC 8511).

Bankhead, Alberta: Hollywood's Canada; making *Sergeant Cameron of the Mounted* on the wooded slopes of the Rockies. Canada's Mounties were probably the most internationally identifiable aspect of the country for years after such movies were shown. (ACR/NA 33-882).

Winnipeg, Manitoba: the Prince of Wales at Union Station on his second visit to Canada, accompanied by his brother George, Duke of Kent. They were celebrating the Diamond Jubilee of Confederation in 1927. (PAM/N-1936).

Vancouver, British Columbia: an Imperial Oil gas station (which also sold cars) at Robson and Seymour, 1928 (CVA/BU.p.613).

For those who still came by boat from a turbulent Europe in the twenties, seeking homes in western Canada, Canadian Pacific was still offering the routes; by ship to Quebec, by rail and/or lake steamer thereafter. These immigrants enjoy the sunshine on the deck of CPR's *Empress of Scotland*. However, the emphasis was also on tourism and visits to friends and relatives. Immigration hostels still existed; these boys sit in front of one across the road from Montreal's Windsor Station; but even the Barnardo children's groups from English city slums were dwindling by the late 1920s. Nevertheless, Winnipeg — "Gateway to the West" — was still a major disembarkation point for Europe's refugees and a nucleus of social ills caused by a dearth of housing and immigrant services. A group of Polish immigrants are shown arriving at Winnipeg's CPR station in 1927.

(CP 22142).

Aboard the *Empress of Scotland*, 1924 (CP 11695).

Winnipeg, Manitoba: 1927. Photographed by Lewis B. Foote (PAM/N-2066).

The Parliament Buildings in Ottawa, with the exception of the exquisite library, under the coned roof at rear, burned in 1916. Rebuilding began almost immediately and the construction is seen in 1920 without the Peace Tower. Across the Ottawa River is Hull, with logs floating near the Eddy Match Company works. Wellington Street, in front of the buildings, was still marvellously treed.

Ottawa, Ontario: 1920 (OA/S-5732).

Regina, Saskatchewan: 1924 (SAB/RB-4188).

The war emphasized the need to be on top of agricultural production, but many prairie farmers were disenchanted with Ottawa and the two-party political system, not to mention the eternal problems of getting grain to market by rail. Farmers embraced co-operatives instead and favoured a whole rash of independent political candidates and parties. The photograph shows bundles of the original Wheat Pool contracts between the Pool and Saskatchewan farmers. It was a time of hope — hope that hinged on developing a "new national policy" based on self-help and determination.

Winnipeg, Manitoba: the huge Canadian Pacific freight yards acted as a physical and profound psychological barrier across the city, separating the working class north end and the middle-class southern section (UCC).

Netherhill, Saskatchewan: c. 1920s (SPL).

Regina, Saskatchewan: pioneer women of the Regina area 1926 (SAB/RB-705).

159

Port Harrison, Ungava: director Robert Flaherty shooting a film, likely *Nanook of the North*, the world's first feature-length documentary, c. 1920 (NPA/MP-156/77).

White Pass Bridge, Yukon Territory: locomotives and caboose of the White Pass and Yukon Railroad, the British-owned railway completed in 1900 from Skagway over the Deadhorse Trail to Whitehorse. The line is quite remarkable in that it has been totally unsubsidized for its eighty-year life. Until the Alaska Highway was built in the 1940s, the railway provided the only land route into the Yukon (ACC/P-7517-429).

Yukon Territory: Reverend F. J. Peck praying with Inuit, date unknown (ACC/P-7502-12C).

Fort Resolution, Northwest Territories: Roman Catholic school children, date unknown. Photographed by H. W. Jones (ACC/P7559-122).

Northwest Territories: whale blubber being winched aboard ship, 1920s (ACC/P-7517-362).

Cambridge Bay, Northwest Territories, Inuit family and home on the barrens, 1927 (ACC/P-7517-311).

Prime Minister Mackenzie King's appearance at the Imperial Conference in London was prefaced by a period of what many saw as a sharp constitutional crisis in Canada. In the election of 1925, King's Liberals slipped from 118 to 101 in a House of Commons of 245 seats. The Tories under Arthur Meighen climbed to 117 and so, it seemed, were in a position to form the government. King held on tenaciously but was trumped by substantiated allegations of a scandal in the customs department. After an acrimonious all-night session on June 25, 1926, the King government was finally defeated.

King went to the Governor General, Baron Byng of Vimy, and asked for dissolution, to be followed by a general election. Remarkably (to King at any rate), Byng refused and instead, employing the Royal prerogative, called upon Meighen to form a government. The Tory leader scraped together what support he could and for three days was Prime Minister of Canada. His inevitable defeat saw Governor General Byng duly dissolve Parliament and call an election. King now trumpeted Imperial interference and much debate raged (and rages still) as to his effect. Byng, after all, had been constitutionally correct.

In any case, King's Liberals went on to win, the basis of victory lying more with the traditional fidelity of Quebec to the Liberal Party than to an electorate concerned with constitutional quandaries.

London, England: the Imperial Conference of 1926; Vincent Massey, Mackenzie King, Ernest Lapointe, and Peter Larkin (Canadian High Commissioner in London) at a London railway station. The Balfour Declaration of November 18, 1926, passed during this Imperial Conference, defined an equal status between Britain and the self-governing dominions. The formal *de jure* recognition of the Balfour Declaration would come in the Statute of Westminster in 1931. (PAC/C-1001)

In the accompanying photograph, the King victory is just beginning to show on the Winnipeg *Free Press* election board. The crowd outside the offices of one of the great Liberal newspapers probably gave little thought to the constitutional issue. The "King-Byng Thing" shows how difficult it is to excite an electorate over constitutional concerns.

Winnipeg, Man., *Winnipeg Free Press* election returns board, 1926.
(PAM/Events 12)

Montreal, Quebec: 1927 (CP18227).

Imperial Oil's refinery in Ioco, British Columbia, was literally carved out of the forest to accommodate storage tanks, staff housing, and plant buildings, including a Canadian Pacific branch line beneath a grandiose mock-Tudor administrative building. Imperial Oil had begun in the 1880s and, by the time of this photograph, was already Canada's largest oil company. Its products would soon be sending a pall of blue smoke and choking fumes into the air of Jacques Cartier Square in Montreal, but in the late 1920s the combustion engine had not quite got the advantage of the horse and cart with the cautious and thrifty Quebec farmers.

Ioco, British Columbia: c. 1920s (IOA-30).

165

Regina, Saskatchewan: 1928 (SAB/RA-6902).

WESTERN FREEDMAN

NATIONAL ISSUE — "The Truth Shall Make You Free!" — Circulation Now 12,000

A Paper Devoted to the Interest of the Protestant Faith and the British Empire

Vol. 1, No. 10. Subscription $2.00 per Year. REGINA, SASK., APRIL 5th, 1928. Single Copy 10 Cents

PROTESTANT CHILDREN COMPELLED TO KISS THE CRUCIFIX AS FORM OF PUNISHMENT

The twenties in Canada were not all peace, joy, and light. Religious bigotry prospered, racial differences festered, living conditions in the largest cities worsened, and unemployment was rising, not falling, as industrial and agricultural production began to lose markets. The election promises of Liberal administrations for comprehensive social insurance, for reciprocity and tariff reductions, for representation of labour in industrial management, and for return of natural resources control to the provinces were not satisfactorily carried out. In Toronto, garbage is dumped in the harbour as landfill; the Harbour Commissioners Building is in the background. Meanwhile, around a wrecked wharf near the Toronto Islands ferry, destitute men grovel for lost coins. But, for some, the twenties were reaching the pinnacle of a head-long rush of greed, excessive productivity, and get-rich-quick profits. The inevitable happened. The world's principal market of profit and loss, the New York stock exchange, crashed on October 24, 1929 — Black Thursday — and Canada experienced her share of the numbing blast. The Depression which followed the crash brought much greater hardship, but the dual disasters would prevent the Canadian economy from recovering until 1937 and would alter drastically the ways in which Canadians thought about their country.

Toronto, Ontario: Photographed by John Boyd (PAC/PA-84921).

Toronto, Ontario: 1926 (PAC/PA-87384).

Winnipeg, Manitoba: a safe broken into at Assiniboine Park, 1929. Photographed by Lewis B. Foote (PAM/N-2636).

The great black-dust storms which scoured southern Alberta and Saskatchewan in the first half of the "Dirty Thirties" ruined the dreams and broke up the accomplishments of hundreds of farmers. Drought followed by wind storms simply took away the top soil and made agriculture impossible. Skies were constantly clouded with the very stuff from which prairie families derived their livelihood. Where twenty-five years before there had been rich, fertile land and enterprising, hard-working immigrant families, now there was a barren desert speckled with bankrupt farmers. In the first picture a farmer in southern Alberta, silhouetted in a gritty storm, grain elevators in the distance, kneels on his land. In the second, a man trundles dejectedly along a dirt-blown track in Saskatchewan. In just under four years, Saskatchewan farmers, who had been the most prosperous in Canada before the Depression, became the least prosperous, and, as the provincial per capita income fell by seventy-two per cent, a period of utter destitution ensued.

Alberta: c. 1929 (PAA/A-3742).

SIX

...Beggarman, Thief

The prosperity, the glitter, and the dazzle so fondly remembered as the mark of the 1920s disappeared for Canadians in the space of one short week in the autumn of 1929. On Thursday, October 24 — "Black Thursday," as it would be universally known — much of the bottom fell out of the New York stock market. Five jittery days later the whole shaky edifice of American corporate finance collapsed. The shock wave rippled through every city, hamlet, and farmhouse in North America.

The great crash soon confirmed the interdependence of the economies of the world, and, sadly, showed how little international co-operation could be found to remedy the slump and Depression which followed. Each country tried selfishly to protect its own markets and economy by the simplistic measure of raising higher tariff walls.

Canadians quickly discovered that they were especially vulnerable because of their large export trade. One-third of all Canadian income came from exports, and two-thirds of this was based on raw materials such as newsprint, minerals, and wheat; prices of which all fell dramatically. Saskatchewan, almost entirely dependent upon wheat production, was, within a few months, almost totally impoverished. Drought and pestilence of a nearly biblical nature — great, thick clouds of omniverous locusts — confirmed the disaster. Saskatchewan farmers in 1928 had sold $218 million worth of wheat; by 1937 that had dropped to scarcely $18 million.

As well, the Depression swept away all the advances made in the social service network so proudly established in the 1920s. The trouble was that the resource base — taxable luxury items — disappeared almost entirely. Debt-ridden provincial governments soon slumped towards bankruptcy as most of those very social services that might have aided their distraught populations closed their doors.

The effects of the Depression were less obvious in the east — especially in Ontario where a mixed economy was better able to weather the storm. In Ottawa, two wealthy men, Prime Minister William Lyon Mackenzie King and R. B. Bennett, the Tory millionaire Leader of the Opposition, were more than adequately insulated from personal financial difficulties. Indeed they appeared to conduct political affairs with little regard for the changed economic circumstances.

Saskatchewan: 1930s (SAB/RA-4823).

Mackenzie King became, in the election of 1930, the first real casualty of the Depression that he had failed to understand. He announced that a federal government under his control would not give a five-cent piece to any needy province with a Tory government. That magnanimous gesture at a time of national need readily assured his defeat at the polls. But the new Prime Minister, Richard Bedford Bennett, was scarcely more perceptive. He vainly tried traditional, conservative actions: tariffs were raised and relief measures increased marginally. The difficulty was that there was no concerted effort, no overall plan to deal with the multiplying problems — only statements of vaguely defined purpose or prime pomposity, such as his naïve election boast that Canada would "blast" its way into world markets.

By 1933, almost one-quarter of the labour force — 826,000 people — was out of work. For many, life became an unhappy round of soup kitchens, flop houses, make-work projects and food coupons. A great number of other Canadians feared that the unemployed would somehow become unhinged and break out in open rebellion. The "On to Ottawa" trek of 1935 — a showing of considerable disgruntlement with minor Communist overtones — and the ensuing Regina "riot," in which a meeting of the trekkers was provocatively broken up by police, showed the extent to which the federal government would go to keep a tight lid on.

Premier "Mitch" Hepburn of Ontario was no less adamant, as was shown by his brutal response to the General Motors strike in Oshawa in 1937. Maurice Duplessis in Quebec was even firmer. His anti-labour government openly frowned on the right to collective bargaining, and introduced the notorious "padlock law," which allowed the Attorney General free rein to shut down any organization if he considered it was being used to spread Communist propaganda.

The federal government, the only government that could effectively deal with all the problems in the country, seemed incapable of taking decisive action, so regional reformers started looking to new political solutions. One was the CCF, the Co-operative Commonwealth Federation, a socialist party firmly implanted in grass-roots prairie agarianism, but sporting a dash of transplanted Fabianism via the League for Social Reconstruction, a Toronto-based group of intellectuals. By 1934 hundreds of CCF clubs dotted the west, and in Saskatchewan and British Columbia the party formed the official opposition.

A different expression of discontent was Social Credit, which found fertile soil in Alberta through the efforts of an ex-school principal and radio Bible-thumper, William Aberhardt. Aberhardt observed that the country was locked in the Depression because of a shortage of purchasing power. The solution: the issue of social dividends or *social credit*. By 1935 the Socreds were in power in Alberta, although they soon scrapped the social credit and proved to be nothing more than another conservative party.

Responding to this radicalism, and influenced by events in the United States, the peripatetic Prime Minister Bennett, in five radio programs openly modelled on American President Franklin Roosevelt's fireside chats, began his version of the American New Deal. Capitalism, the millionaire corporate lawyer Bennett declared, had proved to be defective and therefore must be replaced by government initiative and regulation. There followed a scheme of awesome proportions. Bennett suggested that the state had to establish minimum wages and maximum hours for work, to provide health and unemployment insurance, and to improve the old-age pension. Regulation

was necessary too, he claimed, to oversee wheat marketing, to modify the Combines and Companies Act, and even to overhaul the Criminal Code. Neither the country nor his own party knew what to make of it all, and the legality of such sweeping changes was soon brought into question. Was he an opportunist or simply crazy?

The answer was shaped in the election of 1935 when a chastened Mackenzie King and his Liberals, capitalizing on the unwavering, persuasive slogan "King or Chaos," were returned with a huge majority. Neither King's efforts nor the potential chaos of his opponents actually affected Canada's dismal economy very much. Indeed, the new political solutions seemed to heave up as many difficulties as had the old ones.

Elsewhere in the world other problems were brewing that would again create the universal economic panacea: war. Canada's independent status in foreign affairs had been confirmed after the First World War, but the world hadn't taken much notice. During the 1920s the country had been almost as isolationist as its republican neighbour. In the dictatorial influx which gripped Europe in the 1930s, Canada's chief role was played through the doddering League of Nations, an imperfect instrument at best, and one in which Canada, through the influence of Mackenzie King, played a frequently contradictory role. Some Canadians took a more active role in grappling with the emerging fascist threat: the Mackenzie-Papineau Battalion of the International Brigades received much public support and an equal amount of government censure during the Spanish Civil War. The sell-out of Czechoslovakian interests at Munich was generally well-received by fearful Canadians, and Mackenzie King himself had already shown his faulty perception in a meeting with Adolf Hitler in 1937. King found the Führer sincere, agreeable, harmless, and, for Germany, even desirable. By 1939, when King George VI visited his North American Dominion, Canada remained much as it had started the ugly decade — a country in economic turmoil, in social dislocation, and in a kind of political paralysis. Canada's century had definitely turned sour.

Not everyone suffered as much as wheat farmers on the Prairies, nor did quite as many in the east need as much relief as those in western Canada. Relief, in public or private forms, was usually not the matter of moral acceptance that some politicians and federal officials saw it as. Relief was necessary for plain survival but it brought with it, especially if you were young and single and forced to live in a camp, a searing hopelessness and agony of humiliation. "We see Red...and we think Red," wrote one camp inmate to the *Vancouver Province* in 1935. "Can you blame us? Would you like to have us lie down like a bunch of spineless whelps and be contented as slaves? Is that all our grandfathers toiled for? Canada...young nation...letting her youth go to hell!"

By 1935, over one and a half million Canadians were on some form of relief. In Vancouver, the United Church's Reverend A. Roddan laboured to help men living in the city dump, the so-called "False Creek Jungle." The "Jungle" was destroyed in the summer of 1931, and the men were forced to move to provincial road camps. Many refused to go, and there were constant disputes over costs and the scope of the projects. In the spring of 1932, nearly four thousand unemployed took part in a Hunger March. In the second picture, probably taken in the early thirties, destitute men wait in utter dejection at a board of soup bowls. The location isn't given, but it doesn't matter—the same scene was taking place almost everywhere in Canada.

Vancouver, British Columbia: destitute at False Creek, 1931. Photographed by W.J. Moore (CVA REP. 5).

Early 1930s (PAC/C-29396).

Montreal, Quebec: Adult Women's Club, Rosemount Community Centre, making clothes for families without work or prospects of work, 1930s (McG/2494-368).

Kamloops, British Columbia: trekkers change trains en route to Ottawa, June 1935 (CTA/James 2181).

On to Ottawa Trek

The trek, which began in April 1935 in Vancouver as a protest against relief camps and all they stood for, was one of the most significant events of the 1930s. Its most notorious feature was the famous Dominion Day riot in Market Square, Regina. Royal Canadian Mounted Police and City Police tried to arrest the trek leaders, resulting in the death of a police detective, several injuries, and a number of arrests. In a nation as conservative as Canada the trek is also remembered for the tinges of Communism and revolution, redolent of the 1919 Winnipeg General Strike and faintly similar to the unrest brewing in Europe.

The trek showed the enormous gulf which existed between a society of economic inequity and a government which saw protest as merely a breach of law and order. The events at Regina on July 1, 1935, not only smashed the trek, which had been gathering considerable support as it moved eastward, they also brought to a close some of the worst months of the Depression. Within a year, unemployment was dropping; within two years, wheat production was moving briskly ahead once again, and some of those who had fought against the camps were off to fight even more passionate and terrible battles in Spain. The main demand of the trekkers, the "revolutionary" notion of a guaranteed minimum wage, was never understood either by the government or by anybody else.

Toronto, Ontario: 1935 (YU/*Telegram* 491/3230).

Regina, Saskatchewan: police under attack at riot, July 1, 1935. Photographed by Ken Liddell (SAB/RB-171(1)).

Alberta: 1940 (PAA/A-2048).

Calgary, Alberta: 1940s. Photographed by H. Pollard (PAA/P-5324).

From the Prairies, ever in political ferment, came two absolutely polarised doctrines to grapple with the economic and social mess churned up by the Depression. In Saskatchewan, there arose in 1932 the Co-operative Commonwealth Federation (CCF), which aimed to protect the average citizen and to work for a greater social ownership of the means of production — and its fruits. It was rooted in English socialism, and, because of its rather general platform of being *against* the government and *for* a better deal than poverty, the CCF drew together elements of society that might well have been at loggerheads. CCF influence would grow in Canadian government, as successive federal administrators and the Saskatchewan provincial government moved into more socialist corners.

In Alberta it was Social Credit which rose dramatically in popular approval. Its doctrine offered to take the burden of the Depression off the shoulders of the common man. If farmers couldn't understand how financiers were controlling their lives, let Social Credit experts sort them out. Elect Social Credit and all would be well. The prophet, presenter, and persuader *par excellence* of a doctrine which defended private ownership and management to the hilt was a Calgary high-school principal and fundamental evangelist, "Bible Bill" Aberhardt. His booming voice, heard over the air waves on Sunday afternoons, and at innumerable rallies between 1932 and 1935, when a Social Credit government was elected in Alberta, assured victory for the Social Credit party for years to come. His doctrine was ably continued into the 1960s by Aberhardt's Prophetic Bible Institute colleague, E. C. Manning, seen here beside Aberhardt at a summer picnic in 1940, and by himself in the pulpit of the Aberhardt Prophetic Bible Institute, Calgary. What Albertan, mired in Depression poverty, could resist the richly-timbred tones of Aberhardt pointing out that "you don't have to know all about Social Credit before you vote for it; you don't have to understand electricity to use it . . . all you have to do is push the button and you get the light"?

There was another use for "hot air" — transportation. Germany's supremacy in the airship business had produced the round-the-world capacity ship, the famous *Graf Zeppelin*. Its designer Hugo Eckener was confident that the thirties would be the decade of the Zeppelin-type of airship. Not to be outdone, the British government in 1924 decided that its far-flung empire could best be served by large passenger airships. Accordingly, two programs of construction got under way. The R100, seen in this photograph at St. Hubert airfield in Montreal on the first leg of a two-week round trip in the summer of 1930, was designed by the inventor of hovercraft, Barnes Wallis. Like most of Wallis's work, the R100 performed beautifully and was a model of good design. Its sister ship, the R101, built by the air ministry, was, in contrast, a bungled vessel which crashed in Normandy in 1930, killing forty-eight people. The tragedy put to an end any further British thoughts for rigid airships, and the R100 was sold for scrap.

Montreal, Quebec: 1930 (CTA/James 995).

Manitoba: Devil's Gap Camp and Lodge guests, 1930. Photographed by Lewis B. Foote (PAM/N-1819).

Caughnawaga, Quebec: workmen inside the number 3 caisson of the Caughnawaga Bridge across the St. Lawence River, 1933 (ANQM Mercier).

Port Burwell, Northwest Territories: the Hudson's Bay Company governor, P. Ashley Cooper, addressing local residents, 1934 (SAB/B-1452(5)).

Somewhere in the Maritimes: a telephone operator and his dog, 1934. Photographed by N. Morent (CP/M-2787).

Calgary, Alberta: 1935 (GA/NA-3181-72).

Matapedia, Quebec: waiting passengers are attracted by the cameraman of the Canadian Government Motion Picture Bureau, early 1930s (NBM).

Montreal, Quebec: near the Hibernia playground, 1930s (McG/2494-670).

Quebec: using the Quebec Central Railway by boat during a flood, 1936 (ANQ/GH-673-132).

Vancouver, British Columbia: the new city hall and a streamlined long-distance coach of Pacific Stage Lines — both quintessentially thirties in design, c. 1937 (CVA/CITY p.21).

A banner draped over a Spanish building proclaims Canada's involvement in the Spanish Civil War in 1936-1939. Over twelve hundred men joined the XV International Brigade — less than half of them ever returned to Canada. The men obviously had different reasons for going; in some cases idealism (the fight for the Spanish republic against fascism) was displaced by a real need to be involved in something positive and vigorous after the drab, desultory days of the Depression. Few Canadians understood why the Mackenzie-Papineau Battalion went to Spain, and the Canadian government had to be dragooned into helping the survivors return. Fortunately for the men marooned in Barcelona, often in need of medical treatment, the Communist Party of Canada and Friends of the "Mac-Paps" were there to push and pull. It was not until late February of 1939 that the first men stepped ashore in Halifax; later, in Toronto, ten thousand people gathered at Union Station to meet them. At Massey Hall in Toronto a plea was made for fifty thousand dollars so that Spanish veterans could avoid relief. "Canada didn't understand at first what you were doing, but understands now, and as time goes on, you will have more friends, more, however, because you have done one of the most gallant things done in history," said activist Reverend Salem Bland at the Toronto reception. That was undoubtedly true.

Spain: (probably Barcelona), 1937 (PAC/C-74966).

Vancouver's attractiveness to the unemployed seemed, curiously, to be endless in the 1930s. The relief camp problems were at their worst in British Columbia — after all, the "On to Ottawa" trek had begun there. The failure of that protest had brought about the replacement of the relief camps with railway maintenance camps and temporary winter works camps in 1935. In 1938 these, too, were closed, and the B.C. government refused to do more than help men from other provinces to go home. This led to a sudden sit-in by the unemployed, led by a Communist, Steve Brodie, at the Vancouver Post Office and Art Gallery. Mackenzie King, after almost a month of characteristic stalling, ordered the post office closed. Before 6 a.m. on "Bloody Sunday" (July 26, 1938), Vancouver City Police and RCMP, using tear gas and clubs, cleared the building. Over thirty people, fire policemen among them, were taken to hospital. The Post Office Riot brought to a head — and to a violent end — the enormous social problems caused by unemployment. The riots, together with the rush by some Canadians to fight Franco in Spain, revealed how close to the surface revolutionary fervor of one form or another was in western Canada — in Winnipeg, in Regina, in Vancouver, and in dozens of smaller towns.

Victoria, British Columbia: tin-canner collecting survival cents, 1938 (PABC/A-1657).

Vancouver, British Columbia: 1938 (VPL 1294).

183

Vancouver, British Columbia: postcard sold to raise money during the Post Office strike, 1938 (PABC/C-7946).

Vancouver, British Columbia: city police and RCMP making arrests outside the Post Office, 1938 (VPL 1276).

Vancouver, British Columbia: a victim of police clubbing, 1938 (VPL 1289).

Vancouver, British Columbia: 1938 (PABC/C-7963).

Drumheller, Alberta: protest and social advocacy continued despite (and because of) a reviving economy, 1939 (GA/NA-3472-4).

Port Dufferin, Ontario: growing world tension caused many to consider eccentrics like Burnest Heard with suspicion. The world's greatest lover was thought by some to be a German spy, 1938 (PANS).

Vancouver, British Columbia: a Chinatown window during the Royal tour, 1939 (CVA 6-68).

Regina, Saskatchewan: 1939. Photographed by Ken Liddell (SAB/*Leader-Post*, RB-172).

The excited crowds clustered around this Montreal newsstand suggest that the declaration of war in 1939 met the same general enthusiasm as did the 1914 declaration. In fact, Canada slid into the Second World War, propelled by the momentum of its British past but determined in some fashion to have its own way. This photograph, from the Montreal *Gazette,* was taken on September 3, 1939, two days after the Wehrmacht and Luftwaffe smashed into Poland. Canada would not officially be at war until a week later — after the Canadian Parliament had debated the issue. Neither the *Gazette* nor any other paper seems to have recorded a scene such as this on that day.

Montreal, Quebec: 1939 (PAC/*Gazette* PA-115129).

SEVEN

A Necessary Evil

When Canadians went to war for the second time in the twentieth century, they went by their own decision. Even staunch appeasers relented as Hitler, in a few short months, made the insulting Munich agreement ("peace with honour") quite meaningless. The German invasion of Poland began on September 1, 1939. Britain was at war by September 3, Canada a week later. The Canadian Parliament was almost unanimous in its decision, for there was a strong perception of evil in the Nazi aggression in Europe. For a change, the chief dissenter came not from Quebec but from the west — J. S. Woodsworth, one of the principal founders of the CCF. Both major parties agreed, however, that a fight was necessary and that, if at all possible, the divisive issue of conscription should be shelved. The people themselves showed little exuberance for the war; only a grim determination.

After the fall of Poland, Canada, like France and England, stood aside as the Germans consolidated their hold on eastern Europe. The renewed blitzkrieg in the spring of 1940, the subsequent occupation and surrender of the Low Countries and France, and the entry of Italy on the side of the Axis, prompted a stepped-up Allied commitment.

The Royal Canadian Air Force in 1939 was composed of scarcely forty-five hundred men. The great achievement at home during the war was the establishment of the Commonwealth Air Training Program: ninety-seven flying schools trained over one hundred and thirty thousand aircrew. Canadians took on a considerable bit of the actual fighting. A Canadian squadron flew in the Battle of Britain and Canadian airmen formed an important component of the bomber offensive. By war's end, air force enlistment stood at almost a quarter of a million.

The naval commitment was impressive as well. From ten ships and eighteen hundred men in 1939, the navy grew to four hundred ships and over a hundred thousand crew by the war's end. The main theatre, one which brought the war close to home, was the North Atlantic, where Canadians were engaged in the perilous task of convoy duty.

In 1939 the Royal Canadian Army consisted of some four thousand officers and men plus a non-permanent active militia — "Sunday Soldiers" — amounting to sixty thousand. It was probably one of the worst

equipped armed forces in the world: a pre-war inventory had shown modern weaponry amounting to twenty-nine Bren guns, twenty-three anti-tank weapons, and five three-inch mortars. The transformation of this underprivileged group into an effective fighting force was dramatic. At peak enlistment in 1944, the modern, well equipped army had swelled to four hundred twenty-seven thousand men and women. It had been battle-hardened through the debacle of the Dieppe raid of 1942, the Sicilian and Italian campaigns of 1943, and the Normandy invasion of 1944.

The home front showed changes no less dramatic. A nation with literally no armaments industry at war's outbreak was by 1945 a primary producer of every instrument of war from pistols to self-propelled guns, from aircraft to tanks. In six years, some five hundred escort vessels and minesweepers were built, while at the same time substantial loans and other aid were extended to Great Britain and the allies.

The principal allies were, of course, the frozen constants in the Canadian equilibrium: the United Kingdom, and, after Pearl Harbour, the United States. There was no Imperial War Cabinet as there had been in the First World War, and Canadians did retain control of their own forces. Decisive policy, however, remained with America and Britain, even though such events as the Hyde Park Declaration and the Quebec Conference showed that Canada's extended role was increasingly being recognized.

As in the First World War, manpower was the crucial problem. Women again freed men for fighting by taking on many jobs at home. Canada became once more a nation of bond drives, war stamps, and rationing. Farmers were markedly less upset, and the shrill outcry against profiteering was not so common as had been true in the 1914-1918 war.

Of primary importance again was the question of conscription. Pressures had been brought against King's government to change its anti-conscription pledge in the wake of the fascist over-running of Europe and Japan's eventful sweep through the South Pacific. King decided to hold a plebiscite in April 1942 to relieve himself of a decision on the pledge. The vote revealed, not surprisingly, that Quebec was solidly against conscription. The course of the war saved King, however. No manpower drain was felt until the Normandy invasion and the Canadian drive through Holland. At that juncture a real crisis did emerge, at least politically, but King's intentions had been read by French Canada with approval. When his hand was forced, although there was much grumbling, there were not the open wounds there had been twenty-five years before. Besides, by this time, the war was clearly winding down.

Toronto, Ontario: c. 1940
(YU/*Telegram* 371/2434).

The common image of refugees — long straggling lines of people frantic in their hurried escape from shifting battlefronts — is not apparent in this photograph of British schoolgirls, newly arrived at Toronto's Union Station and looking as if they are about to embark on a school picnic. At first the war seemed just such an illusion to an insulated Canada — no barrage balloons or blackout curtains, little notice of military movement, small change from the placid predictability of everyday life. The period of *sitzkrieg,* the "phoney war" before Hitler's troops turned west in the spring of 1940, extended this sense of unreality.

Ottawa, Ontario: 1940.
Photographed by A. E. Armstrong
(PAC/PA-112714).

Montreal, Quebec: 1942
(PAC/*Gazette* PA-108248).

Canada's legacy from the First World War was, by 1939, neither a sense of nationhood nor particular pride in military achievements. Rather it was the strong recall of political and ethnic division over the issue of conscription. Would the country cleave a second time? Prime Minister King had pledged numerous times that he would never permit conscription for overseas service — but this pledge could only be kept if the war progressed without a call for massive amounts of manpower.

A national peacetime draft law had been established in the United States in September of 1940. Canada, a country at war, made no more than a gesture with the National Resources Mobilization Act in June 1940. This gave the government the power to conscript able-bodied men for service at home but not abroad. The National Registration, which accompanied the act, caused some concern. Camilien Houde, the Mayor of Montreal, called on his fellow French-Canadians to ignore the regulation. He was promptly interned for the duration. In the first of these photographs, clerks are shipping the registration forms out to the provinces. In the second, Henri Bourassa speaks out vehemently against conscription.

In effect, then, Canada had two armies; a conscripted army for service at home and a volunteer army for overseas service. Remarkably, there was a greater flood of volunteers than had been seen in the First World War. An emotional outpouring saw nearly every part of the country make a massive manpower commitment, and a call came that Canadian troops should be seen taking part in the actual fighting. Some further shouted that the conscripts should be absorbed and all circumstances in the Canadian army be made the same. In 1942, Mackenzie King's government, under great pressure, conducted a plebiscite asking to be released from the previous commitment against conscription for overseas service. As expected, English Canada overwhelmingly endorsed the idea but French Canada was resolutely opposed.

The most famous Canadian photograph of the Second World War: "Wait for Me, Daddy", by C. P. Dettloff, staff photographer with the *Vancouver Daily Province,* shows Private Jack Douglas Bernard, his wife Bernice, and their fair-haired son Warren Douglas, caught in a poignant movement that reflects so many of the tensions of any country at war. Bernard was in The British Columbia Regiment, (Duke of Connaught's Own Rifles), and the photo was taken on Eighth Street in New Westminster. It has been reproduced many times since, both in Canada and abroad, and has won a number of international photographic prizes. Private Bernard survived the war and was reunited with his family.

New Westminster, British Columbia: 1940. Photographed by C. P. Dettloff (CVA. Mil. P. 203).

Canadians might have been slow to realize that they were involved in "total war" but the machinery of the war-time economy was soon in place. At first there was a marked lack of enthusiasm on the part of the British about buying Canadian war materials. All this changed after Dunkirk and the collapse of France. When the Battle of Britain and the deadly blitz threatened British industry, the orders poured into Canadian manufacturers — and the demand increased for the fruits of Canada's vast agricultural lands. Soon a Department of Munitions and Supply was established; then a Defense Purchasing Board to maintain control of all purchases, foreign or Canadian. Tax breaks and credits were extended to private industries involved in the war effort, and, by the end of the conflict, Canada ranked as number four producer among the allied powers. The full run of war materials was produced — from ships to aircraft, from tanks (here, a Valentine produced at the Angus machine shops of the Canadian Pacific in Montreal) to poison gas (here being loaded at the Stormont Chemical Plant for shipment to Dartmouth, Nova Scotia).

Montreal, Quebec: c. 1941 (CP 19773).

Near Cornwall, Ontario: c. 1941 (PANS).

1943 (PAC/C-68669).

The wizard of Canada's massive war production was Clarence Decatur Howe — American-born, and Massachusetts Institute of Technology-educated Minister of Munitions and Supply in King's war cabinet, seen here at the wheel of the five hundred thousandth vehicle produced for the war effort. Howe's energy and willing desire to extend governmental largesse in the form of capital cost allowances, tax credits, and massive incentives for research and development greatly helped the transformation not only of Canada's primary industries but also its secondary industries. As well, throughout the war vast new sources of raw materials were discovered — and anxiously gobbled up by the war needs of the Allies. Howe was both loved and hated and has been credited — a bit too enthusiastically — as being the central force that dragged Canada out of the Depression. After the war, when "getting things done" became more art than science, criticism about Howe's Yankee ways and connections mounted.

Total war meant that, although Canadians were removed from the dangers of direct attack (one Japanese submarine *did* lob a few shells near Victoria) the fears were always there. But monotony was the most common price of war on the home front. The official emblems of a country at war were everywhere — on posters, on radio, on billboards. A lexicon of words from the home front would include: censorship, propaganda, rationing, sabotage, sacrifice, patriotism, service, freedom, liberty, profiteering, duty, and honour. War work was deemed as vital as service in the forces, and, as in the First World War, many women volunteered for factory work, nursing, or military duty.

Cityscapes took on a tired, shabby look. For a time new passenger cars were impossible to get and household appliances had to be patched up and repaired as often as clothing. Luxury items imported from abroad entirely disappeared and the alcohol content of beer and liquor was reduced. Travel became difficult, not only because of gas rationing but because there was really nowhere to escape from the war.

The war had a levelling effect — a strong indicator of the government's ability to impose rigorous strictures on prices and supplies. Unemployment insurance and the "baby bonus" would be benefits of the swing to greater government control. While Canadians concentrated on the war effort a welfare state was emerging on the home front.

Fort Erie, Ontario: A pile of scrapped license plates brought from Buffalo to aid in a Canadian Red Cross scrap metal drive, 1941 (IOA).

Saskatoon, Saskatchewan: The Fourth Victory Loan Campaign Tableau, 1943. The "four freedoms" and a good number of other symbols of the allied cause ranging from Christianity to international co-operation are jammed onto a single stage and guarded by everything from Boy Scouts to army cadets. Roman numerals IV stand obviously for the four freedoms. The V also means Victory, and the I is broken into the Morse code signal "...–" for V, a sound heard on British broadcasts during the war. Photographed by Leonard Hillyard. (SPL)

Montreal, Quebec: McGill University students sent to help harvest grain in Saskatchewan, 1942 (PAC/*Gazette* PA-108360).

London, Ontario: A postman delivers permanent ration books to Mrs. William Brockett and six of her ten children, 1942 (PAC/C-26110).

Montreal, Quebec: Sealing and marking at a community canning plant (McG/Acc. 2494 No. 703).

Vancouver, British Columbia: Woodward's Department Store, 1941 (VPL 25644).

Toronto, Ontario: Contents of a Christmas box sent by Eaton's to all employees on active service (EA).

199

Toronto, Ontario: A bingo game at the staff carnival to aid the Eaton's Employees War Auxiliary, 1942 (EA).

Alberta: Royalite Oil Crew, 1943 (IOA).

Ontario: Prisoners of war (YU/*Telegram*, 366-2404).

Women in the Second World War were encouraged to join not only the labour forces. In July of 1941, the CWAC, the Canadian Women's Army Corps, had been formed, followed by the RCAF (Women's Division), and the Women's Royal Canadian Naval Service. The "quacks," as they were called, drove trucks, handled office chores — in fact, performed most of the same functions as the men except for the actual fighting. They did this, incidentally, for 90¢ a day as opposed to the $1.30 given to male privates. By war's end there were almost forty-five thousand women in the service as well as forty-five hundred military nurses.

Winnipeg, Manitoba: (PAM/CAP 162)

Parachutes bumping behind them, three pilots make their way toward Harvard trainers. They are a part of one of the most successful of Canada's home-based war efforts — the British Commonwealth Air Training Plan. Outlined in a series of discussions with British officials before the war, the plan was sketched in as early as September 1939. It was finalized in December of that year with an official agreement among Britain, Canada, Australia, and New Zealand. The aim of the plan was to train pilots in the dominions, and in spite of acrimonious debates between the mother country and Canada almost every step of the way, it was an enormous success. Fifty-five per cent of the more than one hundred thirty thousand pilots, bombardiers, radio operators, air gunners, and navigators who graduated eventually served in the RCAF. The plan cost Canada over a billion dollars, but it created forty-five Canadian air squadrons and meant that twenty-five per cent of the aircrews operating under British command on western fronts were Canadian.

Ottawa, Ontario: 1940
(DND -PL 2164/Lo18430).

Near Halifax, Atlantic Ocean: 1941 (PAC/DND PA-105344).

To Canadians, in one sense the war did not occur overseas at all. The sea brought much of the conflict unfamiliarly close, and naval engagements were fought in the Gulf of St. Lawrence. Canada's particular task in the war at sea was to escort convoys that assembled in Bedford Basin at Halifax and took the long, slow, and dangerous route eastwards across the Atlantic to besieged Britain. The Battle of the Atlantic might well have been the most important of the war and at its height fully half of the convoys sailed at least part of the way under Canadian protection. The work-horse of this tedious, risky chore was the Corvette. This photograph, taken from the Corvette HMCS *Chambly,* shows two more Corvettes, the *Orillia* and the *Cabot.* Eventually more than a hundred were built, some 190 feet long by 33 feet wide, with a four-inch gun and racks of 400-pound depth charges to be used against submarine predators. Corvettes were cramped, austere, perenially wet inside, and floated like a cork in a bottle, but they were effective and they were cheap.

The enemy without's counterpart, of course, was the enemy within — or at least what was perceived to be the enemy within. Thousands of people were interned in Canada, not a few of whom were brought from Britain and elsewhere for that express purpose. Many were innocent of any crime except that of not being born a British subject. Japan's surprise attack on Pearl Harbor unleashed a wave of anti-Oriental sentiment both in western Canada and the western United States. The "Yellow Peril" idea had long been popular amongst the red-necks, and the conflict with Imperial Japan gave them an opportunity to legitimize their racism. The government at Ottawa obediently bowed to British Columbian political power, and, under the authority of the all-powerful War Measures Act, a mass evacuation of Japanese-Canadian citizens (many Canadian-born) began in February of 1942 with the internment of "Male Enemy Aliens" between the ages of eighteen and forty-five. Eventually nineteen thousand were shipped out, away from the "vital" areas like Steveston and Vancouver, forced to sell cheaply or give up their property and belongings, and re-settled in crude camps in interior B.C. It was, without question, the most outrageous violation of civil rights in Canadian history, particularly as military officials and the RCMP had firmly declared that the Japanese-Canadians were not considered to be any threat whatsoever.

Vancouver, British Columbia: 1942 (VPL 1342).

Steveston, British Columbia: 1942 (VPL 1397).

Vancouver, British Columbia: 1942 (VPL 1345).

The most perceptible change brought by the war was Canada's shift further into the American orbit. Superficially the war suggested a closer co-operation amongst all English-speaking peoples and a clear North American community of interest. In fact, Canada's emergent role was continually snubbed and downplayed by both Britain and the United States. Perhaps Mackenzie King's position, to the rear of both Churchill and Roosevelt at the Pacific War Council meeting, is appropriately symbolic.

Nevertheless, the obvious need for some scheme of hemispheric defense, especially after the fall of France and during the Battle of Britain, drew Canada tightly to the United States. In August 1940 the Ogdensburg Agreement established a Permanent Joint Board of Defence as an advisory body to "consider in the broad sense the defence of the north half of the western hemisphere."

Economics forced an even closer coupling. Britain's need for war supplies upset the traditional nature of Canada's balance of payments. Normally Canada had a surplus of exports to the United Kingdom and imports from the United States. Now more material was needed from the United States so imports increased, but the complementary increase of American purchases *from* Canada didn't. Britain's dwindling currency reserves didn't help the matter — Canada soon faced huge deficits. The Hyde Park agreement of 1941 helped to solve the problem. The United States and Canada agreed to supply each other with the defense materials that either partner could produce most efficiently and conveniently. Now Canada's mounting deficit fell away slice by slice and an anxious Britain could make needed purchases directly in the United States through lend-lease, or in Canada, through lend-lease dollars.

After the United States became an active combatant in the war, and Canada had declared against Japan, American air bases were established in Canada, making sights like this American plane over the legislative building in Edmonton commonplace. The American 18th Engineers Regiment Brass Band playing before a tumbledown log cabin at Kluane Lake in the Yukon, however, retains a touch of the bizarre. The engineers ("a welcome army of U.S. soldiers") were in Canada to build the Alaska Highway. This mammoth project to link Alaska with the states eventually called "the lower forty-eight," required the construction of a fifteen-hundred-mile road through some of the most challenging mountainous country engineers had ever faced.

Washington, District of Columbia: 1942 (PAC/C-16670).

Edmonton, Alberta: 1943 (PAA/A-1954).

Kluane Lake, Yukon Territory: 1942 (YA Macbride MUS 3976).

Vancouver, British Columbia: 1945 (VPL 26543).

Certainly one of the great changes brought by the war was the political swing to the left — a swing that saw the CCF emerge as the provincial government of Saskatchewan in 1944. Tommy Douglas (centre), who would soon become provincial premier, stands before a CCF billboard in Weyburn, Saskatchewan. Until the war, the party, formed in 1932 under the leadership of J. S. Woodsworth, had succeeded in becoming the official opposition in a number of provinces. The war, however, brought state controls and social planning, as well as a huge increase in the membership of trade unions. All this kindled an interest in democratic socialism. That interest became particularly acute as the war carried on and victory became certain. Canadians, it seemed, were not willing to take risks in perilous times such as in the Depression, but in times of rising expectations a new way appeared at least worth a try. In Landis, Saskatchewan, a group of farmers watches and listens diligently at the citizen's conference on co-operative farms.

Weyburn, Saskatchewan: 1944 (SAB/RB-2895).

Landis, Saskatchewan: 1945. Photographed by Visual Education Photo, Regina (SAB/S-B821).

A troop train, c. 1944 (CP 8128).

By the autumn of 1944, with the invasion of Europe and its attendant manpower drain, the question of conscription again raised its head. Although voluntary enlistment from Quebec had been more enthusiastic than during the First World War, the province was still somewhat behind the rest of the country in number of enlistments. Part of the reason doubtless was the language used in the services. With the exception of a few units in the army, the forces operated solely in English. As well, industrial expansion resulting from the war had driven many able-bodied Quebecers into important war industries jobs. There were other difficulties too. Many leaders of Quebec public opinion were open in their sympathy for France's Vichy government and their hostility towards the anti-Christian regime of the USSR.

In August of 1944 the Canadian Army had taken almost ten thousand casualties. Colonel J. L. Ralston, the Minister of Defense, was convinced that volunteers could not fill the void; the sixty thousand semi-trained draftees at home had to be readied for overseas duty. Prime Minister King balked; Ralston resigned, precipitating a split in the cabinet.

General Andrew McNaughton, former Commanding Officer of the Canadian Army, a man convinced that volunteers could still meet the needs, was called by King to the defense portfolio. Recruiting did pick up, but it still couldn't provide the necessary trained troops quickly enough. King was forced to announce that sixteen thousand troops in the home defence forces would be made available for overseas duty. The Air Minister, who sat in a Quebec seat, resigned in protest and French Canada was again rocked by violent demonstrations.

However, casualties for the rest of the war were relatively light, and this greatly vindicated the Prime Minister. Besides, it was clear to French Canada and to everyone else that he had conscientiously attempted to avoid a ruinous confrontation and had only endorsed a form of conscription when completely boxed in.

209

Victory

For Canada and Canadians the war ended on May 8, 1945. Some eighty thousand Canadian soldiers volunteered to carry the conflict to Japan, but their services were unnecessary after the atomic bomb was dropped in August. Almost forty-two thousand Canadians would not return from the war — but more than a million who had been in uniform would. And what kind of a country would greet them?

Canada, if not exactly transformed by six years of war, certainly was different. The war effort had cost the country about $20 billion and the federal debt in 1945 stood at $13 billion. In exchange, Canada had been converted, at a dizzying pace, to a manufacturing country. The intelligence and leadership that had caused this industrial blossoming had been gotten for a patriotic song. Rank upon rank of successful businessmen had been employed by the federal government at one dollar a year for the duration of the war; the benefits would spill over into the post-war era.

Socialism had raised its head as well, and was pronounced not nearly as ugly as everyone had feared. In fact, some were arguing that socialism was the only way to preserve the old social values. Their argument was that somehow capitalism had caused the war, and had perished in the fighting. That was naïve but it certainly seemed that in Canada at any rate the old pre-Depression days were forever gone. The war had been the crucible of the modern welfare state, the most obvious example of which was the "baby bonus" — the Family Allowance Act. The first baby bonus payments were dispatched in July of 1945 — scarcely two months after VE day.

Winnipeg, Manitoba: c. 1945 (PAM/CAP-15).

Halifax, Nova Scotia: 1945
(PAC/C-79574).

Naturally, the end of the war brought celebrations; some pleasant, some jarring. The most conspicuous example of the latter was the VE Day riot in Halifax. Twenty-four thousand soldiers and sailors stationed in and around the port city had felt a strong sense of resentment towards the place. Many saw Halifax as a smug, privileged city that had turned its social back against the servicemen and servicewomen who, it made clear, were unwanted guests. The inevitable VE Day street parades grew wild and then wilder. Troops soon smashed into liquor stores and kept smashing. Eventually five hundred businesses were damaged and over two hundred looted before order was restored.

Halifax, Nova Scotia: 1945 (EA).

Alberta: 1945. A more dignified celebration, typified by this hospital orderlies' dance, was the order of the day in most of Canada (PAA-GS-2/1).

Halifax, Nova Scotia: 1946 (PANS).

A happy legacy of the war was the arrival, at government expense, of an army of some forty thousand war brides (mainly British) and their twenty thousand children, most under the age of three. Canadian servicemen, it appeared, had scarcely spent their long service in wartime Europe in vain.

Readjustment was inevitably the watchword of the immediate post-war years. The volume of manufacturing increased substantially and this brought about a general rise in the standard of living. The expansion of Canada's range of natural resources was most spectacular. Oil, natural gas, iron, and uranium were all discovered in large quantities, enhancing Canada's reputation as a primary producer of world commodities. Seven of the country's leading industries were engaged in processing primary products, by far the largest being Canada's old staple, wood. The Canadian pulp and paper industry supplied half the world's newsprint by 1950. By 1955, total production value of pulp and paper was $1600 million. Both pulp and paper and aluminum were given a boost by the surge forward in the development of hydro-electric power. The most momentous of all industrial boosts, however, was the 1947 oil strike at Leduc, just south of Edmonton, by Canada's own petroleum giant, Imperial Oil. For the average citizen, all of this meant increased opportunities for employment. And yet, as the seaman's strike in Saint John showed, the underbelly of Canada's economy was always vulnerable: "Do you want to go back to the Hungry Thirties?" and "Is this the beginning of Post War Canada?" the strikers' placards warned.

Calgary, Alberta: Henderson Secretarial School, 1940s (PAA/P-8682).

214

EIGHT

The True North

War had once more brought great change to Canada. All of the problems of the aftermath of the first war, it was feared, would have to be faced again. As well, the political complexion of the country had altered. For the first time in Canada a socialist party, the CCF, had been elected as a provincial government (in Saskatchewan) and was the official opposition elsewhere. Trade union strength had greatly increased during the war, and had finally united with stalwart farmers to assure electoral victory. The war had also brought a virtual end to British power in the world — although this passing would take a while to effect — and had seen the emergence of two new "superpowers", the United States and the USSR, both neighbours of Canada.

The rise of the CCF caused a good many politicians to take stock of their electorates and, in turn, to modify their policies to suit the changed times. The Ontario Tories' wartime "22-point program," for example, stole some enthusiasm from the CCF (and in many ways still forms part of the governing credo of Ontario). Nationally, the Liberals began, as early as 1943, a flirtation with social security that would end in a love affair. By 1944, social programs were being promised for a happier post-war world: a world of full employment, unemployment insurance and family allowances.

The shift from war to peace turned out to be nearly effortless. Veterans were given extensive allowances, training, and educational opportunities which led to jobs. The post-war slump simply did not develop. Indeed, by 1948, the economy was humming, and that key indicator, the automobile industry, positively booming. Gross National Product from 1945 to 1948 increased an impressive twenty-five per cent.

Of course, much of the explanation for the sudden prosperity lay in the wartime destruction of Europe, the open acceptance of Keynesian economics, and closer ties to the United States. Nevertheless, Canadians, more than ever before, could claim a large slice of the credit — and the action.

The late 1940s and the 1950s were characterized by the spread of electronic mass communications, modern transportation techniques, an unprecedented urban migration to the suburbs (predicating thousands and thousands of housing starts) and, of course, the "baby boom." The

fast-rising birthrate put immense pressure on all social services which, in turn, demanded an expansion of everything from hospitals to schools and universities. All this was given impetus by cheap, abundant energy, a buoyant stock market, a relatively tranquil labour movement, and a stolid, predictable political scene under Mackenzie King and his successor, Louis St. Laurent.

Canada's status in international affairs moved to a new prominence. Pre-war prevarication was replaced by active involvement and commitment. By 1947, a Canadian Citizenship Act had given Canadians a status somewhat more substantial than that of British Subjects. By 1949, the old high tribunal for Canada, the Judicial Committee of the Privy Council in London, was at last dethroned; the country finally took over its own judicial affairs. In fact, all but one or two of the strings linking Canada to Britain were gone. The tautest string, the Monarchy itself, judging from the reception accorded the new Queen Elizabeth II before, during, and after her Coronation in 1953, remained popular with new as well as old Canadians.

Canada had not played an instrumental role in the establishment of the United Nations, but soon came to be an important middle-power on that stage. The establishment of NATO (North Atlantic Treaty Organization) and, much closer to home, NORAD (North American Air Defense Command), moved both Canada and the United States a good distance from thoughts of isolationism. Canada's growing global role was demonstrated in the Korean War, and in the mushrooming of Canadian missions abroad — from six in 1939 to more than forty by 1957.

An event of both national and international importance was the addition of a tenth province. In the depths of the Depression, Newfoundland had been forced ignominiously to revert to colonial status. During the war, the island had been revitalized by its key position in the North Atlantic security system. The decision of this oldest British colony to join Canada was by no means unanimous, but under the influence of a smooth-talking radio personality, Joseph Smallwood, the vote shifted eventually to a majority for Confederation. By 1949, Canada could boast that it was a little wider than coast to coast and Joey Smallwood could boast that he was Canada's only living Father of Confederation.

The pinnacle of Canadian influence in international events came during the Suez crisis of 1956. Canada turned fully against its Anglo-French heritage and condemned the reckless incursion of the two Imperial powers into the middle East. United Nations ambassador Lester Pearson's suggestion that a special United Nations Emergency Force be created defused the whole affair and set a model for future UN initiatives. It earned Pearson a Nobel Peace Prize, and at home, broke the trail for his election, first as leader of the Liberal Party, and then as Prime Minister.

But Canadians were tiring of that Liberal government — aged, fat, and complacently arrogant. This disgruntlement came to a head in June of 1956 when the government employed the parliamentary tactic of closure four times to stop debate and push through a pipeline bill. The following year the Conservatives, under the control of a charismatic westerner, John Diefenbaker, managed to form a minority government, followed in 1958 by a landslide victory.

John George Diefenbaker may have seemed to be the right man, but it was definitely the wrong time. The great boom cycle was slowing down and unemployment in 1957 had climbed to 1939 figures. Canadians felt the

crunch of competing with their over-valued dollar against a restored Europe and Japan.

Prosperity had also brought other changes, the effects of which would not be apparent for a time. The 1950s saw the establishment in Canada of a lively artistic life unparalleled in the nation's drab, derivative cultural existence. The Stratford Theatre was an example of not just national but international excellence, and the same high reputations were being enjoyed by the National Film Board and even by the beleaguered CBC. A permanent agency, the Canada Council, proved definitively that the federal government was committed to supporting not only the arts but the artists, was created in 1957.

Most Canadians in the 1950s still seemed a complacent lot. The land was fat and the living seemed notoriously easy — despite the occasional gloomy prediction of a cold warrior. Resurgent prosperity, however, had blinded many to the fact that an unimpeded, narcissistic consumer ethic was flowing vigorously from south of the border. Nobody seemed to recognize much danger; nobody rose to criticize. What was right for General Motors was right for Canada too — wasn't it? The 1960s would shake this comfortable complacency.

Valois, Quebec: suburban commuters on the Montreal lakeshore line, early 1950s (CP2782).

Toronto, Ontario: Canada's first car radio-telephone, 1947. Photographed by John Boyd (BTC-25436).

Alberta: Atlantic No. 3 well with overflow in foreground, c. 1949 (IOA).

Saskatoon, Saskatchewan: bagging flour at the Saskatchewan Wheat Pool mill, 1949 (SAB/RB-7613).

Montreal, Quebec: Canadian Pacific's Angus shops went back to building and servicing locomotives, 1948 (CP8679).

Northern Quebec: skins are hauled on a sledge drawn by a Caterpillar tractor, 1946 (CP 8814).

Saint John, New Brunswick: merchant seamen protested reductions in fleets and appealed to Prime Minister King to prevent lay-offs, 1948 (DUA).

Black Diamond, Alberta: employees of Imperial Oil in the local hotel, 1945 (IOA/A-88).

Lachute, Quebec: a police officer guards a pile of rocks destined probably to be thrown at "scabs" at Ayers Mill, 1947. Photographed by Jack Markow (PAC/*Gazette* C-53637).

Saskatchewan: farmers' strike, 1940s (SAB/S-B829).

"Come near at your peril, Canadian wolf!" went the popular song that expressed Newfoundland's traditional reluctance to join Confederation. In 1935, hard-hit by the Depression and on the verge of bankruptcy, Newfoundland's government was taken over by the British Colonial Office. The war years brought Newfoundland once again into the military and economic fray and, relatively speaking, there was some recovery in the years after the war — certainly enough for Britain to suggest a three-way referendum to Newfoundlanders: should they maintain the status quo, strike out as an independent dominion, or join the Canadian federation? By a fairly slim majority, Newfoundlanders took to heart the urgings of Joey Smallwood, a St. John's radio broadcaster, and opted for Canada. The date of entry was — some thought fittingly — April 1, 1949. Smallwood became provincial premier for the next twenty-two years. On the blank shield waiting hopefully above the doorway arch to Parliament in Ottawa, Prime Minister Louis St. Laurent chipped in the first notches of Newfoundland's coat of arms. St. Laurent, who lived to see the centennial celebrations of a *whole* country (or so it appeared) in 1967, regarded the acquisition of Newfoundland as the most significant event of his political career.

Conception Bay, Newfoundland: a squidjigger (PAC/PA-11457).

Ottawa, Ontario: 1949 (PAC/C-6255).

A factor not often taken into account in Canada's post-war economic flourish is the great baby boom. The Depression had not in any sense proved a fertile period, particularly in English Canada, but by the beginning of the war a shift was discernible. In 1945, the year the troops came back, the trend set in with authority — in one year the number of births jumped from 24.4 to 27.2 per 1000 of the population. This was coupled with a low death rate and augmented by waves of immigration. Canada's population climbed steadily every year until the country could boast one of the highest birth rates in the world. By the 1960s, however, the pace was slackening; it fell off to a steady 15 births per 1000 in the 1970s.

The sudden swell in the size of younger population of the country manifestly changed all the economic predictions, indeed, the baby boom of the 1940s and 1950s changes them still. Particularly affected were the social service institutions, schools, universities, playgrounds, and hospitals, but actually every aspect of the society would experience some change.

Drink Milk Campaign, 1947 (PAC/PA-93682).

Montreal, Quebec: c. 1940s (McG, Acc. 2494/769).

Hamilton, Ontario: the Sixth Annual Eaton's Model Aircraft Contest at Hamilton Civic Airport, 1946 (EA).

Alberta: lemonade stand, 1949 (PAA/GS-481).

The 1950s were the age of the conspicuous consumer — and, of course, the manufacturer. Once more the mentality of big business governed the popular psyche, especially through media advertising, although this time it appeared that everyone just might be able to have a slice of the pie. Bigger and better were the signposts of the 1950s, buttressed by a confident growth in the Gross National Product, which doubled from $18 billion to $36 billion. Most impressive was the extraordinary housing boom — $60 billion worth of new housing and construction went up in that single decade. Canada, as a consequence, became a land increasingly dominated by suburbs, shopping centres, superhighways, and the automobile upon which they all depended. All of this was accompanied by a gush of consumer products ranging from the increasingly flashy family car to luxurious, although frequently unnecessary, household appliances. Wages went up dramatically as well, and the consumer price index, which in the 1980s shoots upward like a thermometer on a hot day, shifted only twenty-eight per cent during the whole period.

Kitchener, Ontario: Opening day of a new Eaton's department store, 1949 (EA).

Edmonton, Alberta: Kraft products display, 1948 (PAA/GS-256).

Ottawa, Ontario: Westinghouse new products, 1954. Photographed by Andrews-Newton (COA/A-N 30 4 11).

Canadian Pacific Railway passenger train: c. 1950s (CP 539).

Aboard the *Empress of Britain:* 1956 (CP 17267).

Prince Edward Island: c. 1950 (PAPEI2973).

225

Ottawa, Ontario: 1950 (PAC/PA-93704).

Winnipeg, Manitoba: visit of Princess Elizabeth, 1951 (PAC 17823).

Cypress Hills, Saskatchewan: Bob Breen proudly displays buck mule deer he has shot, 1958 (SAB/RB 8440 2).

Charlottetown, Prince Edward Island: c. 1950s (PAPEI2930).

In the spring of 1950, almost the entire metropolitan area of the City of Winnipeg, divided by the Red River, was inundated by a flood of epic proportions. Afterwards the city built a series of stout dykes and conduits to guard against an expensive repeat. Prime Minister Louis St. Laurent viewed the stricken city from the roof of the Manitoba Sugar Refinery. Many, like this unhappy couple surveying the results of the flooding were left homeless, but the Lord would provide, at least He did for these enterprising nuns paddling down an avenue of graceful elms.

Winnipeg, Manitoba: 1950 (PAM/Flood albums 3176).

Winnipeg, Manitoba: 1950 (PAM/Flood 1950 457).

Winnipeg, Manitoba: 1950 (PAM/Flood 1950 16).

228

The first meeting of the Canadian Labour Congress in April 1956 marked a realisation that the Co-operative Commonwealth Federation (CCF) would need a broader base for its survival and that the Canadian Labour Congress and Trades and Labour Congress would provide the best platform for a merger. The convention produced two major resolutions which paved the way for a more concerted move towards a new party (the New Democratic Party, which was formed in 1961): one was a political education program designed to get unions interested in political matters, the other was an agreement to co-operate in legislative and political action "excluding communist and fascist dominated parties." British and American flags and the Canadian ensign were much in evidence at the podium. The rear murals, expressing hope and progress, are an interesting European style of graphics.

Toronto, Ontario: 1956. Photographed by *Canadian Tribune* (PAC/PA-93490).

Calgary, Alberta: 1956 (PAC/PA-108139).

Corporal Walsh of the 1st Battalion, Queen's Own Rifles of Canada, poses with his family in 1956 as the United Nations flash is stitched onto his uniform prior to his leaving for the Middle East. Canada's peacekeeping role following the Suez crisis was her second major contribution in this vein since the end of the Second World War. Corporal Walsh had served also with the 25th Canadian Infantry Brigade in Korea in 1951. Peacekeeping was a role which Canada began to play more often as international tensions crackled through the next twenty-five years, and it was one which was specially favoured by the Prime Minister of the middle 1960s, Lester B. Pearson — himself a recipient of the Nobel Prize for Peace for his widely applauded efforts in Suez.

Prince George, British Columbia: c. 1950s (PABC/F5599).

Two railways, two parties, two premiers. The British Columbia government's hope for the future rested on the promise of the provincial government railway in opening up the rich extractive mineral prospects of the B.C. interior. The man who promised to bring in the new era was its buoyant Social Credit premier W. A. C. Bennett, here seen opening a stretch of the PGE (Pacific Great Eastern) railway north of Vancouver. East of Ottawa, an aging benevolence still presided in the person of "Uncle Louis," Prime Minister St. Laurent. In rural eastern Ontario on a peculiarly Canadian type of hustings — the rail car — St. Laurent is trying to keep the Diefenbaker wolf from the door in the late spring of 1957 — without success.

Alexandria, Ontario: 1957. Photographed by Andrews-Newton (COA/AN-50602).

Toronto, Ontario: a reporter finds a story amongst men outside the Scott Mission on Spadina Avenue, mid-1950s (PAC/PA-93923).

Ottawa, Ontario: a municipal employee relaxes at curbside, 1956. Photographed by Andrews-Newton (COA/AN-43837).

Ottawa, Ontario: "New" Canadians rest outside the "Y" before tackling the hurdles of Canadian living, 1957. Photographed by Andrews-Newton (COA/AN-50534A).

Northern defence in Canada has increasingly been the concern of the United States government. The Distant Early Warning (DEW) Line is a case in point. Like its predecessor, the Pine Tree Line, it was very much an answer to the nuclear missile threats that grew up in the 1950s. The object was to provide a linkage of manned stations, such as this one in the eastern Arctic, throughout the North American Arctic that would give early warning of air attacks to the populated areas of the continent. At Hall Lake in the Northwest Territories, Minister of Transport George Hees and Mrs. Hees inspect a DEW Line station built, as they all were, by the American government, and manned jointly with Canada.

Hall Lake, Northwest Territories: 1958.
Photographed by Ted Grant
(PAC/PA-108140).

Eastern Canadian Arctic: 1956.
Photographed by G. Lunney
(PAC/PA-108141).

The Vision of the North

La Ronge, Saskatchewan: early morning mineral-claim stakers lined up at the provincial recording office for copies of new survey maps, 1957. Photographed by Alan Hill (SAB/Ph.A.C.-57-311-01).

James Bay, Quebec: c. 1960. Photographed by Armour Landry (ANQM/2031).

233

Pond Inlet, Northwest Territories: waving to men of Coast Guard ship *d'Iberville* (ACC/NFB-83317).

Northwest Territories: watching a movie (ACC).

James Bay, Quebec: surveyors, c. 1960. Photographed by Armour Landry (ANQM/2031).

James Bay, Quebec: teaching English, c. 1960. Photographed by Armour Landry (ANQM/2031).

235

Placards...

Toronto, Ontario: outside the U.S. embassy, 1971. Photographed by MacGregor (YU/*Telegram* 168-1147).

NINE

Even in the Best of Families

For much of the fifteen years between the end of the Second War and 1960 Canada seemed an earnest sophomore amongst the nations of the world — eager, able, growing in confidence, respected for its achievements, but not yet ready for the big leagues. Beginning in 1960 this picture of buoyant vigour began to crumble, leaving Canada's face not only bruised, but deeply etched with the lines of experience and inner turmoil.

Much of the upbeat pace of the 1960s and 1970s was set by Quebec. That province underwent a tumultuous transformation from the measured satisfaction of *la survivance* to a vigorous, sometimes strident, reaching for independence and a separate nationality. Both were beyond reach, at least for the time being, and Quebecers would remain confused about how to define the essential nature of their society. This uncertainty was all the more understandable because the province had been violently pitchforked in a dozen short years from being a conservative, religious, close-ordered and moral society into one not merely in the modern industrial mainstream but part of the vanguard of North America and Europe.

Politicians provided much of the driving force in this change although, unlike other parts of the country, the underpinning of political culture in Quebec became increasingly intellectual. The "Quiet Revolution" begun by Jean Lesage's Liberal government in 1960 was a revolution, in true 1960s style, of hearts and minds. Quebecers took hold of their past and forcefully shook it free of its cloying sentimentalism, then, using the tools of a new class of bright, well-educated social scientists and technocrats, they redesigned their government and much of their society in a peculiarly distinctive mode. Some became entirely enamoured of the process and saw its logical end as separation from the rest of the country; others viewed it, less passionately, as the mechanism by which a better deal within Canada could be achieved. A great amount of the nation's time and energy, and no small portion of its cash, were taken up by the demands of these two groups of Quebecers. When the debate was finally and formally fashioned into a referendum in the spring of 1980, the clear victors were the moderates, those who, to use a phrase from an earlier period, had sought a "better deal" for Quebec in Confederation.

It is not too dramatic to suggest that the process had transformed the way Canadians saw themselves, and had initiated further refinements in the nature of the country. By the 1960s and 1970s, Canada had become something the Fathers of Confederation had never envisaged: a coast-to-coast bilingual and bicultural country — by law. It had also become the most decentralized federation in the world, one in which a new fourth arm of government was felt — the all-powerful court of the federal-provincial conference. Pierre Trudeau, who had inherited the embryo of this new style of government from Lester Pearson, didn't exactly remake the country in his own image, but for a while he did make his own image that of the country. The country "dined out" on Pierre Trudeau, that most un-Canadian Canadian, and for a period his lifestyle was either loved or detested but always followed with an interest which no Canadian Prime Minister had ever invoked before. After the post-Expo exuberance had faded, and Trudeau had proved merely mortal, his technique, many argued, shifted from Philosopher-King to Mackenzie King.

Nevertheless, Canadians held on to him and his tarnished Liberals through oil crisis, inflation, and constitutional confrontation. They complained about the high cost of government, fretted over minority rights and worried about Vietnam, welfare, Yankee imperialism, and nuclear power. A brief flirtation with the Conservatives and their leader Joe Clark so resurrected Trudeau's credibility and stature that he was able to sweep to power again and welcome the country, on behalf of his party, to the 1980s.

Quebec might have set the pace; others in the field of provincial rights were close to follow. Regional inequalities forced a perpetual crisis for any federal government. The Maritimes may not have had political clout or economic leverage, but the west certainly did, particularly after the Arab oil embargo in 1973. Western resource development became crucial, and a jealous wrangle arose over tax rights, pipelines, and other fiscal privileges or shackles which firmly and inevitably juxtaposed the industrial east against the resource-rich west. The fact that the federal majority, the Liberals, held almost no western seats in Parliament dragged out the whole question of Canadian unity anew.

Actually, most Canadians now took their nationality (if not their nation) for granted. What was being worked out — perhaps for the first time — was a precise definition of Canada, in literary as well as legal terms; in a cultural as well as a constitutional sense. By the 1960s and 1970s national cultural institutions like the CBC and the National Film Board had matured and burst forth in a creative surge. A veritable cornucopia of Canadian "Kultur" descended upon a generally enthusiastic audience. New publishing houses, theatres, orchestras, and galleries made Canadian a style as well as an adjective — to Canadians at any rate.

A cultural definition certainly proved less elusive than a constitutional one. By late 1980 it was clear that the process of the federal-provincial conference was two-edged and the federal government gracelessly retreated to a more tried and traditional modus for constitutional change. Failing to secure agreement with any province other than Ontario and New Brunswick, Trudeau prepared unilateral legislation for approval in Westminster.

One of the great limitations of the vicious internal squabbling in Canada during the 1960s and 1970s was that it caused a sharp deviation from the much-respected international role Canada had assumed in the 1950s. Pierre Trudeau was an internationalist more by temperament, taste,

and intellect than by practical effort. Many Canadians lamented the retreat from international respectability and felt Canada had forsaken a unique opportuniiy to exert its particuliar status and prestige among the nations of the third and fourth world. Instead Canada and much of the Commonwealth became a gracious Old-Boys Club, full of polite, cultured declamations but little else. Canada retreated too from its vigorous United Nations role and adamantly refused to concede that it was part of the Americas rather than some extension of distant Europe. Increasingly, other people of the world saw Canada as a lesser United States. A lot of Canadians felt that way too.

Certainly the country prospered materially, but the basis of this well-being relied too much upon foreign investments — especially from the United States. Most Canadians were salaried employees, but since the salary was high, it was hard to focus criticism. Government efforts to redress the ownership balance of the economy seemed toothless.

Still there was much to cheer about. In the balance Canadians formed a wealthy, comfortable society, one perhaps in which excellence mattered less than it might, but at least the pie seemed large enough, in economic and cultural terms, for everybody. Thousands from around the world continued every year to strive for a share. Canada offered most of its people a good life, and for those looking in from beyond its borders a better life. A price certainly had to be paid for all this in terms of foreign control of the economy but Canadians were nothing if not satisfied customers.

Montreal, Quebec: 1960 (PAC/*Gazette*. PA-115130).

Ottawa, Ontario: unemployed rallying at Landsdowne Park prior to marching to Parliament Hill, 1961 (YU/*Telegram* 491-3230).

Toronto, Ontario: 1961. Photographed by Frank Grant (YU/*Telegram* 168-1147).

240

Toronto, Ontario: 1965. Photographed by Dick Loek (YU/*Telegram* 167-1146).

Sydney, Nova Scotia: protesting the threatened close-down of the Hawker-Siddeley plant, 1967 (PAC/C-98715).

. . . and the Placid

Toronto, Ontario: Miss Canada contestants, 1973 (YU/*Telegram* 149/1041).

241

Symbols of Sovereignty

The *Rassemblement pour l'Indépendance Nationale* (RIN) founded in 1960, was the first separatist movement of any importance in Quebec politics. From it, other splinter groups, like the *Ralliement National* (RN), broke away, and it was unable to rejoin with more conservative Quebecers or moderate *separatiste* groups like René Lévesque's *Mouvement Souveraineté-Association*, formed in 1968, which provided the nucleus of the *Parti Québécois*. As this photograph might imply, RIN developed a reputation for street demonstrations which more often than not ended in clashes with the police. This particular protest coincided quite deliberately with the visit of Queen Elizabeth to Quebec City at the request of Premier Jean Lesage, following her visit to Charlottetown to celebrate the centenary of the Quebec Resolutions — a monumental date in nation-building. Apprehension was high long before the Royal arrival in Canada, never mind in Quebec City. The whole affair was to be a test of Quebec feelings about English Canada, a conclusive event. The worst happened — few people turned out to cheer the reigning monarch, insults were hurled ("Vive Elizabeth — Taylor"), rocks were thrown, and Laval students were brutally clubbed by Quebec police.

Montrealers were already acutely aware of the terrorist violence perpetrated in their streets by the *Front de Liberation du Québec* (FLQ), whose bombs were "planted" at places such as military barracks, and also randomly scattered throughout cities in mailboxes for maximum effect.

The divisions between French and English Canada were never more symbolically visible than in the "Great Canadian Flag Debate." In its heat and passion the Debate tied up parliamentary business for nearly six months in 1965. In the end, Prime Minister Lester Pearson won out with the now familiar Maple Leaf, and the Leader of Her Majesty's Opposition John G. Diefenbaker lost his battle to retain the old British Red Ensign. The nub of the matter was summed up in Diefenbaker's cry, "I want to make Canada all Canadian and all British," and Pearson's indignant rejoinder, "Am I supposed to be forgetting my British past because I look forward to my Canadian future?" On February 15, 1965, a raw wintry afternoon, the new flat was unfurled.

Quebec City, Quebec: 1964
(YU/*Telegram* Neg-9A).

Montreal, Quebec: 1963 (PAC/*Gazette*.
PA-115131).

Ottawa, Ontario: Governor General Georges P. Vanier, Prime Minister Lester B. Pearson, and Leader of the Opposition John G. Diefenbaker at the inauguration ceremony of Canada's flag, 1965. Photographed by Ted Grant (NFB Photothèque 65-180).

The Ties That Bind

Estimates of the cost of Expo '67 have varied as widely as they did for the costs of Mayor Jean Drapeau's more recent spectacle, the 1978 Olympic Games, but $650 million is not far off. And yet, 1967, Canada's centennial, was a marvellously colourful and reassuring year for Canadians. One journalist wrote of centennial year as "a brief shimmering season in the long wash of history, a mass rite that managed to expose the latent patriotism in even the most cynical Canadians, leaving them a little embarrassed at their sentiment, a little surprised by their tears." The World's Fair, in the middle of the St. Lawrence River and a stone's throw from what many thought of as North America's most vibrant city, seemed to sum up not only what Canada had done in a hundred years, but also to point to where she was going.

Singing "O Canada" in bilingual unison or skipping to Bobby Gimby's "C-A-N-A-D-A" in July 1967 was a euphoria that suddenly evaporated when French President Charles de Gaulle arrived in Canada. Quebec provincial premier, Daniel Johnston, accompanying de Gaulle in this motorcade, had been received virtually as a head of state in Paris only two months previously. De Gaulle's itinerary was planned meticulously by all governments concerned; it was plain that Ottawa, Quebec, and France all aimed to extract mileage from this momentous visit at such national celebrations. The French President was to tour Quebec City, driving along *le chemin du roy* to Montreal, greet Drapeau, see Expo '67, and spend thirty-six hours in Ottawa before returning to Paris. In Quebec City he shouted *"Vive le Canada dans son ensemble!"* but at Montreal, before a wildly cheering crowd, he dramatically cried *"Vive Montreal! Vive le Quebec! Vive le Quebec libre!"* The tumult of the crowd prevented anyone hearing as he also shouted *"Vive le Canada Français!"* and, inevitably, *"Vive la France!"* Lester Pearson, shocked at what seemed an intolerable intrusion into Canadian affairs, despatched a stiff note to de Gaulle, who left the country abruptly.

Just three days before de Gaulle's arrival, Lester Pearson and his wife Marion had dressed up for Klondike Days celebrations in Edmonton.

Montreal, Quebec: 1967 (PAC/C-18536).

Quebec City, Quebec: 1967 (PAC/*Gazette*. PA-117531).

Edmonton, Alberta: 1967 (PAA/J-152).

"Saskatchewan's short, slight titan of the tongue," Tommy Douglas, brought the Co-operative Commonwealth Federation Party (CCF) to power in Saskatchewan in 1944. Canada's first "socialist" government produced distinct tremors in commercial circles but Douglas proved adept at finding room in Canada for private enterprise too. Indeed, despite the alliance with organised labour which produced the New Democratic Party in 1961, Canada's socialist political parties have shown little signs of doctrinaire programs or inclinations. Tommy Douglas left Saskatchewan to take up the NDP policies and organization federally. Here he is seen in a typical stance deep in Conservative territory at Edmonton's Jubilee Auditorium.

Edmonton, Alberta: 1968 (PAA/J-221).

At the federal-provincial conference in February 1969, Pierre Trudeau was flanked by Gordon Robertson, Clerk of the Privy Council, and Mitchell Sharp, who had competed with him the year before for the leadership of the Liberal Party. Trudeau's balancing act between the west, at that time generally supportive, and a truculent Quebec with noisy *separatiste* leanings, was only just beginning. To many Quebecers' consternation, Trudeau was seen and heard to be a very strong federalist indeed.

Ottawa, Ontario: 1969. Photographed by Duncan Cameron (PAC/PA-117465).

Steveston, British Columbia: 1973 (CVA/29-16).

One of the strongest ties that binds Canada and Canadians — hockey — is symbolized by this group of young bubble-gum chewing fans in Steveston, British Columbia.

Leaving the Nest?

In September 1970, the British Trade Commissioner in Montreal, James Cross, was kidnapped by the *Front de Liberation du Québec* (FLQ), an event which was closely followed by the kidnapping of Pierre Laporte, the Quebec labour minister. To deal with the emergency, Pierre Trudeau invoked the War Measures Act. This Act, which allowed government the right to exercise discretionary "arrest, detention, exclusion, and deportation" in time of war, had last been used during the Second World War to remove Japanese-Canadians from the west coast. In 1942, the action had met with almost universal approval across Canada; in 1970, it provoked some vigorous protest, typified by this march down an Edmonton street. Most Canadians, however, accepted with equanimity the presence of troops on city streets. in fact, Trudeau and the Liberals enjoyed a sudden surge in popularity, particularly after the safe recovery of James Cross and the deportation of his captors. Sadly, Pierre Laporte's murdered body had earlier been found in the trunk of a car in St. Hubert.

Montreal, Quebec: c. 1968. Photographed by David Marvin (NPA).

Edmonton, Alberta: 1970 (PAA/J-522.2).

Vallée, Quebec: 1963 (NPA).

Edmonton, Alberta: Hungarians demonstrate outside the Ukrainian Centre, 1970 (PAA/J-442).

Montreal, Quebec: Claude Ryan and René Lévesque, 1970s (PAC/*Gazette*. PA-117480).

Edmonton, Alberta: Russian Premier Alexei Kosygin, just named Honorary Chief Gold Eagle, sits with Alberta Premier Peter Lougheed, 1971 (PAA/J-737/5).

Edmonton, Alberta: civic election camp — wrestler Gene Kiniski at right, 1971 (PAA/J-733/1).

Edmonton, Alberta: city police at a "be-in," 1971 (PAA/J-612/4).

Edmonton, Alberta: Canadian Indians supported their American brothers, 1973 (PAA/J-959/3).

Breaking Through

Edmonton, Alberta: women at work.
Interior of the GWG jeans plant, 1968
(PAA/J-181/2).

Edmonton, Alberta: women at work.
Fashion models display the latest
swimwear in midtown Edmonton, 1969
(PAA/J-471/5).

Edmonton, Alberta: women protesting.
An abortion rally, 1970 (PAA/J-446/3).

The Great Canadian Debate

The great Canadian debate is, of course, how can Canada discover its own identity when so much of its economy, capital accumulation, cultural life, and defensive position is either foreign controlled and owned or materially affected by values almost impossible to describe as uniquely Canadian? The Committee for an Independent Canada holds that drastic reduction in American industrial control and ownership would allow the Canadian identity to become more visible. On the other hand, the media guru of the period, Marshal McLuhan, observed that Canada was unique in being able to live, if not contentedly at least enduringly, *without* an identity. The debate goes on, despite such perverse put-downs, and the CIC persists into the 1980s.

Edmonton, Alberta: 1973 (PAA/J-112/1).

Regina, Saskatchewan: winter view looking west over Albert Street, c. 1961. Photographed by Dean (SAB/RB-5556(1)).

Montreal, Quebec: Peel Street south of McGregor Avenue. Remnants of Canada's Scottish heritage still remained in 1970. Photographed by David Marvin (NPA).

EPILOGUE

Plus ça change

A visitor from another planet whose spaceship had visited Canada at Confederation and then touched down over a century later in the early 1980s might not see a great deal of change in the essential outlook of the country's people. Canadians, in fact, still seem to be grappling with the same problems; they still have the same concerns. There is still "too much geography" and little can be done with vast portions of it. The climate, notwithstanding the best efforts of modern technology, still determines a lot of the nature and scale of the economy. Much of that economy still stamps Canadian as hewers of wood and drawers of water. The British-American balance has certainly shifted markedly over the years, but the affairs of the two largest English-speaking nations still affect Canadian life to too great a degree. Britain's influence in Canada has waned to no more than a cousinly link, but the Queen of England is still Queen of Canada, and the Parliament at Westminster still casts shadows on our constitutional affairs. The United States appears to own us lock, stock, and barrel, although the British still cling fiercely to a fair chunk of that stock. More than ever, America influences our affairs and our style of life. An interlocked commerce gives Canadians too little control over their own economy, and just as it was in the 1860s, 1870s, and 1880s, it is still feared that this economic penetration will be followed by political initiatives.

We probably have more to fear from the sprawling influence of American culture, especially the impact of television, which chains — or more appropriately, cables — Canada to the tireless pumps of American popular values. Nevertheless, most Canadians remain — in principle if not personally — firmly anti-American.

A definition of Canada continues to be as elusive as ever. Officially bilingual and even bi-cultural, the country is, in fact, something less than the sum of its provincial parts. Whatever the final outcome of constitutional arguments, Anglo-French relations remain the constant core of Canadianism. Besides, even if the country were to split up along linguistic or cultural lines, a "Canadian community" would persist. And that's a phrase that would have been understood in 1867.

Montreal, Quebec: c. 1970. Photographed by Roger Charbonneau (NPA).

Krestova, British Columbia: 1962 (PABC/C-6543).

Wardner, British Columbia: Antoine Rosicky and his dogs, 1970. Photographed by Stanley G. Triggs (NPA).

Index

Aberhardt, William, 170, 176, *176*
Aitken, Max, Lord Beaverbrook, 82
Aitken, Reverend William, 82, *82*
Alberta, 33, 46, 59, 74, 89, 91, 142, 147, *154*, 168, *168*, 176, 211

Banff, 39, 51, *51*, 93, *93*
Barkerville, 27, *27*
Bathurst, 56, *56*
Batoche, 48, 66
Bennett, R. B., 118, 169, 171
Bennett, W. A. C., 230, *230*
Bonanza Creek, 67, 73, *72-73*
Borden, Robert, 77, 88, 121, 127, 128
Boston Bar, 26, *26*
Bourassa, Henri, 76, 84, 192, *192*
British Columbia, 10, 25, 26, 28, 30, 32, 35, 36, *38-39*, 40, 52, 55, 64, 170, 204, 230
Brown, Ernest, 59, 60, 74

Calgary, 112
Cameron, W. B., 50, *50*
Canadian Broadcasting Corporation, 217, 238
Canadian Pacific Railway, 31, 32, 39, 40, 42, 43, 51, 53, 60, 64, 78, 91, 92, 93, 118, 134, 153, *154*, 157, 159, *159*, 165, 194, *219, 225*
Canadian Women's Army Corps, 201
Cannington Manor, 92
Capilano Canyon, *94*
Charlottetown, 32, 153, 242
Chicoutimi, *111*
Chilkoot Pass, 67, 70, 71, *71*
Clark, Joe, 238
Committee for an Independent Canada, 251, *251*
Co-operative Commonwealth Federation (CCF), 170, 176, 189, 208, 215, 229, 245
Cormack, George Washington, 67
Cross, James, 247

Dawson, 67, 69, *69*, 70, 71, 73
Dead Horse Creek, 35, *35*
Depression, the, 146, 166, 169-187, 195, 208, 210, 216, 222, 223
Detloff, C.P., 193
Diefenbaker, John, 216, 230, 242, *243*
Douglas, T. C., 208, *208*, 245, *245*
Doukhobors, 90, *90*, 91
Doyle, Sir Arthur Conan, 127, *127*
Drapeau, Jean, 244
Dufferin, Lord, 36
Dumont, Gabriel, 47, 66, *66*
Dunsmuir, Sir James, 25, 55, 63, *95*
Duplessis, Maurice, 170
Durham, Lord, 12, 146

Eaton Co., the T., *108, 109*, 131, 199, 200, 223, 224
Edmonton, 60, 74, 91, 113, 205, *206*, 214, 244, 245

Emerson, 64, *64*
Expo '67, 238, 244, *244*

First World War, 76, 88, 119, 121, 124-143, 146, 147, 171, 190, 192, 196, 209
Flaherty, Robert, 160, *160*
Fraser River, 26, 44, 66
Fredericton, 28, *28*

Goderich, 20, *20*
Grand Trunk Pacific Railway, 30, 55, 91, 127
Groome, Reginald John, 147, *147*

Halifax, 16, 32, 33, *33*, 39, 182, 203, 211
Hamilton, 18, *18*, 223
Hees, George, 232, *232*
Hegg, E. A., 69, 71, *72-73*
Hochelaga, 29, *29*
Houde, Camilien, 192
Howe, C.D., 195, *195*

Île Ste Helene, *see also* St. Helen's Island, 13
Imperial Oil Company, *156*, 165, *165*, 214, 220
Indians, 43, *43*, 46, *46*, 47, 62, 66, 71, 81, *81*, 120, *161, 249*
Inuit, *160, 161, 162, 233, 234, 235*

Kaiserhof Hotel, 130, *130*
Keefers, 40, *40*
King George V, 81
King George VI, 171, *187*
King, William Lyon Mackenzie, 163, *163*, 164, 169, 170, 171, 183, 190, 192, 195, 205, 209, 216, 220, 238
Kingston, 23, 86
Komagata Maru, S.S., 119, *119*

Lachine Canal, 86
Lachine Rapids, 86, *86, 87*
Lacombe, Father Albert, *104*
Laporte, Pierre, 247
La Tuque, *85*
Laurier, Wilfrid, 31, 32, 75, 76, 77, 84, 89, 91, 127
Lesage, Jean, 237, 242
Lorne, Marquess of, 30, 33, 92
Lougheed, Peter, 248

Macdonald, Sir John A., 16, 31, 35, 39, 50, 52, 75, 92
Mackenzie-Papineau Battalion, 171, 182, *182*
Manitoba, 24, 32, 35, 52, 75, 88, 89, 91, 93, *136*, 147, *178*
Manning, E. C., 176, *176*
Massey, Vincent, *163*
Maynard, Robert, 26
McGill University, 54, *54*, 197
Meighen, Arthur, 163
Métis, 32, 46, 47, 49
Moncton, 127, *139*
Montreal, 13, *13*, 15, 23, 29, 34, *34*, 39, 42, 55, 76, 86, *86*, 115, 128, 141, 157, 165, 188, 192, 194, 252

Montreal General Hospital, 65, *65*
Mowat, Oliver, 32, 52

Nanaimo, 25, *25*, 55
Nares, George Strong, 34
National Film Board, 217, 238
Netherhill, 159, *159*
New Brunswick, 10, 11, 12, 14, 85, 238
New Democratic Party, 229, 245
Newcastle, 82, 121, *121*
Newfoundland, 10, 83, 216, 222
North-West Rebellion, *see also* Riel Rebellion, 48, *48*, 49, *49*, 60
North-West Territories, 24, 33, 34, 46, 91, 92, 93
North-West Mounted Police, *see also* Royal Canadian Mounted Police, 32, 45, 47, 60, *60*, 64, 71, 93
Northwest Territories, 161, 162, 232, 234
Notman Bros., 13, 22, 23, 29, 30, 33, 34, 46, 53, 54, 87, 111
Nova Scotia, 10, 11, 12, 55, 122, 142, 147

Ontario, 11, 31, 32, 35, 52, 75, 93, 130, 145, 146, 147, 169, 170, 215, 238
Ottawa, 10, 23, *23*, 24, 30, 36, 39, 46, 58, 60, 91, 138, 158, *158*, 244
Ottawa River, 23, 24, 55, 158, *158*

Pellatt, Sir Henry, 149, *149*
Pont-Neuf, *85, 135*
Port Moody, 42
Portage La Prairie, 33
Prince Albert, *48*
Prince Edward Island, 10, 32, 52, 58, *123*
Prince of Wales, *156*
Prince Rupert, 91, 127
Princess Elizabeth, *226*
Princess Louise, 30, 33

Quebec, 11, 12, 32, 76, 84, 91, 126, 128, 138, 139, 142, 147, 163, 170, 189, 190, 209, 237, 242, 244, 246
Quebec City, 17, *17*, 22, 23, 29, 57, 77, *110, 111*, 147, *147*, 157, 242, 245
Queen Elizabeth II, 216, 242
Queen Mary, 81
Queen Victoria, 10, 33, 82

Red River, 24, 32, 64, 228
Red River Expedition, *24*
Regina, 46, 47, *47*, 49, 89, 91, *113, 114*, 128, *129*, 159, 165, 174, 183, *252*
Riel, Louis, 24, 32, 47, 49, 50, 66
Riel Rebellion of 1885, *see also* North-West Rebellion, 32, 47
Rocky Mountains, 24, 25, 32, 39, 51, 127, 156
Royal Canadian Army, 189, 209
Royal Canadian Mounted Police, *see also* North-West Mounted Police, 142, 156, 174, 183, 204
Royal Canadian Navy, 76, 189
Royal Canadian Air Force, 189, 202

Royal Canadian Air Force (Women's Division), 201
Royal Flying Corps, 147
Ryan, Claude, 248

Saguenay River, 77, 86
St. George, 78, *78*
St. Helen's Island, *see also* Île Ste Helene, 29, 34
St. Hubert, 177, 247
Saint John, 14, *14*, 23, 53, *53*, 214
St. John's, 83, 222
St. Laurent, Louis, 216, 222, 228, *228*, 230, *230*
St. Lawrence River, 10, 22, 23, 24, 29, 34, 57, 77, 86, 244
Sandon, 79, *79*
Scott, Thomas, 24, 32
Second World War, 145, 188-213, 229, 237, 247
Sherbrooke, *115*
Sifton, Clifford, 89, 90, 119
Skagway, 67, 160
Smallwood, Joseph, 216
Smith, Amor de Cosmos, 44
Social Credit, 170, 176, 230
South Saskatchewan River, 66
Steele & Co., 93
Strathcona, Lord, 51, *104*
Swift Current, 49

Topley, William, 30
Toronto, 15, *15*, 23, 39, 52, 76, 86, 127, 128, *129*, 131, 133, 149, 152, 166, 191
Trudeau, Pierre Elliott, 238, 246, *246*, 247

United Nations, 216, 229, 239
United States, 11, 24, 25, 32, 36, 75, 76, 77, 170, 190, 192, 205, 215, 232, 239

Vancouver, 37, *37*, 42, *42*, 43, *43*, 55, *55*, 68, *68*, 69, 119, 120, 150, 151, *156*, 172, 174, *181*, 183, 184, 185
Vancouver Island, 25, 36, 80
Vancouver Post Office Riot, 1938, 183, *183, 184, 185*
Vanier, Georges P., 243
Victoria, 36, *36*, 55, 80, 95, *95*, 130, *130*, 140, 196

Whitehorse, 67, 160
White Pass and Yukon Railway, 67, *104*, 160, *160*
Winnipeg, 24, 39, 40, *40*, 69, 76, 88, 90, 93, *114, 116, 124*, 127, 128, *129*, 141, 143, 148, *148*, 151, 155, *157*, 164, 167, 183, 228
Winnipeg General Strike of 1919, 126, 142, *143*, 174
Women's Royal Canadian Naval Service, 201
Woodstock, 18, *18*, 20
Woodsworth, J. S., 189, 208
Woodward's Department Stores, *199*

Yale, 44, *44*
Yellowhead Pass, 127, *127*
Yukon, 67, 68, 70, 160, 161, 205
Yukon River, 67, *67*

NEW MAP OF THE
DOMINION OF CANADA
PRINCE EDWARDS ISLAND,
NEWFOUNDLAND,
Including a General Map of all
BRITISH NORTH AMERICA.
PUBLISHED BY
H. H. Lloyd & Co.
21 JOHN ST. NEW YORK.
1871.